Published by Tuttle Publishing, an imprint of Periplus Editions
(HK) Ltd., with editorial offices at 364 Innovation Drive, North
Clarendon, Vermont 05759 U.S.A.

Library of Congress Cataloging-in Publication Data
Self, Caroline, 1919-
 Chinese brush painting / Caroline Self and Susan Self—1st ed.
 p. cm.
 Includes bibliographical references.
 ISBN-13: 978-0-8048-3877-1 (hardcover)
 ISBN-10: 0-8048-3877-1 (hardcover)
1. Ink painting, Chinese—Technique. I. Self, Susan, 1949-
 II. Title.
 ND2068.S45 2007
 451.4'251—dc22 2006037838

ISBN-13: 978-0-8048-3877-1
ISBN-10: 0-8048-3877-1

Distributed by

North America, Latin America & Europe
Tuttle Publishing
364 Innovation Drive
North Clarendon, VT 05759-9436 U.S.A.
Tel: 1 (802) 773-8930
Fax: 1 (802) 773-6993
info@tuttlepublishing.com
www.tuttlepublishing.com

Asia Pacific
Berkeley Books Pte. Ltd.
130 Joo Seng Road #06-01
Singapore 368357
Tel: (65) 6280-1330
Fax: (65) 6280-6290
inquiries@periplus.com.sg
www.periplus.com

First edition
11 10 09 08 07 10 9 8 7 6 5 4 3 2 1

Printed in Singapore

CHINESE BRUSH PAINTING

a hands-on introduction to the traditional art

 Caroline Self and Susan Self

TUTTLE PUBLISHING
Tokyo · Rutland, Vermont · Singapore

This book is dedicated to
all the children in the world
who would like to develop new skills
using the brush.

Acknowledgments

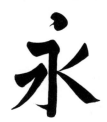

We thank Sherry Kendrick for her advice and especially her help in doing calligraphy. Thanks to the Barbara Bauer Literary Agency for all their help.

contents

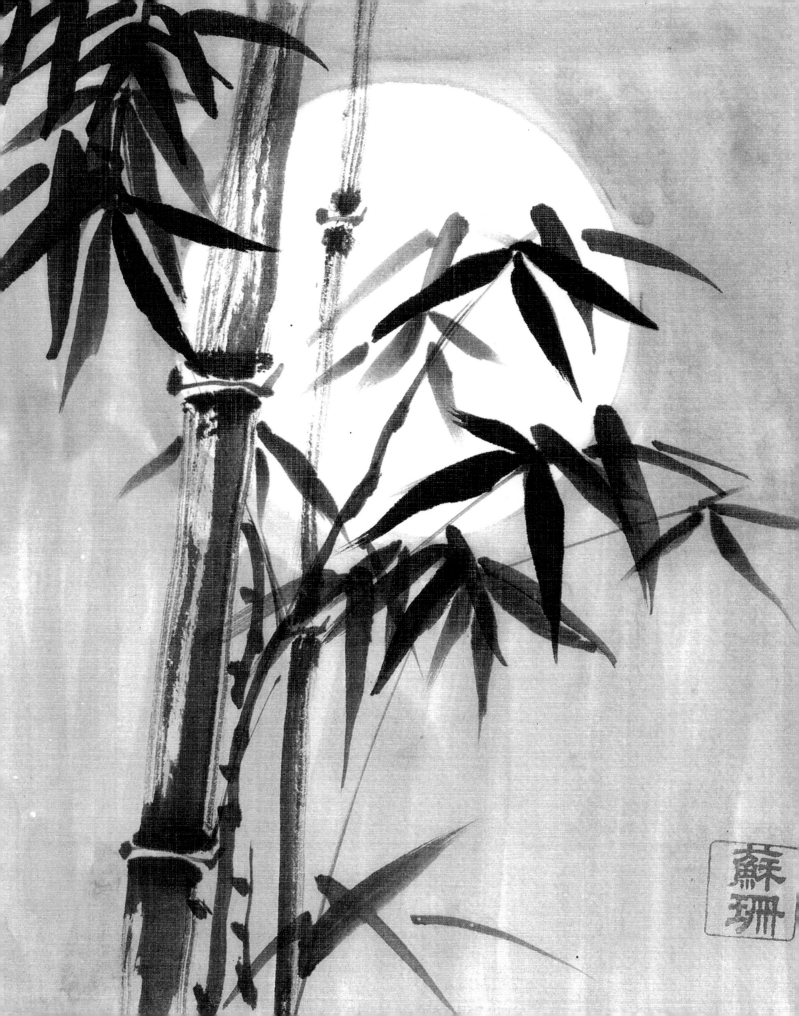

HOW TO USE THIS BOOK

This book is for kids at least seven years old, teens, and adults—anyone who wants to learn about the traditional Chinese way to write words and make paintings. You can read about and make the paintings on your own, or you can read the book with a parent or teacher, a brother, sister, or friend, and talk about what to do and why. Someone who knows about painting can be a big help.

This book shows you how to hold the brush Chinese-style and make the basic brushstrokes. You will learn to write some words and numbers in Chinese. Then you will learn how to use the same basic brushstrokes to create pictures of classic Chinese subjects, including orchids, bamboo, pine trees, and landscapes. This book explains how Chinese artists think about these subjects and what principles and traditions they follow in painting them. After you copy some examples and understand the principles, you can make your own designs. When you have completed some paintings, you can choose from several suggested ways to mount them for display.

You may wonder why the paintings in this book are not in color. The reason is that traditional Chinese paintings used only black ink. Different mixes of gray were treated like colors. Later, the Chinese added a few colors. After European styles became known in China, brush painting became more and more colorful and started copying Western water-color styles. The older and simpler way of painting started to be ignored. This book tries to keep the older tradition alive. Its beauty comes from lines and shapes, shades of gray, and contrast between black, gray, and white. Chinese brush paintings are interesting just as black-and-white photography is interesting in its own way, without using color.

To do brush painting, you must learn to control the brush with your eyes, your arm, and your mind. When all three work together, you will be surprised at how great your Chinese-style paintings can look. You will learn new tricks with the brush that you didn't know before. Brush painting takes a lot of practice, but it can also be a lot of fun and make you feel happy because of what you have learned and accomplished.

The Roots of Chinese Painting

Centuries ago in China, the first writers, whoever they were, made lines in the sand with their fingers. Then they added another line and another, until the designs reminded them of objects they had seen. The wind blew, and the images disappeared. Later, they found sticks and made marks in the hard dirt. Again, the lines suggested objects.

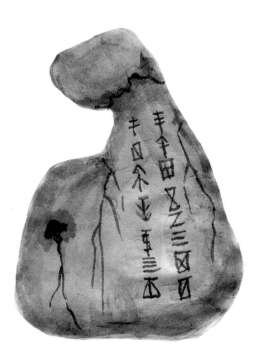

Oracle bone

Meaningful Scratches

Such drawings were the beginning of written language in China. They are called *pictographs*. Five marks put together in a certain order looked like the sun, so the group of lines was read as "sun." Other lines put together looked like mountain peaks and were read as "mountain."

Researchers have discovered pictographs scratched onto turtle shells and the flat shoulder bones of animals. These are sometimes called "oracle bones" because they were used for telling the future. The practice dates back to around 1500 B.C., during the Shang dynasty. About 5,000 different pictographs have been discovered. They represent animals, plants, natural elements, manmade objects, and human beings.

Later, people wrote pictographs in ink with brushes on silk or paper. Over time, the pictographs changed from images of objects to symbolic figures called *characters*. New characters are always being added, so that today the Chinese language has over 50,000 characters. Many of these are not used very often. In China today, people learn how to speak and write about 2,800 characters for everyday use. A highly educated person learns at least 4,000 to 5,000 characters. So kids in China need to spend a lot of time learning to read and write characters.

Calligraphy

Writing a character with a brush is called *calligraphy*. This word means "beautiful writing." Calligraphy has been very important throughout Chinese history. Learning to write characters correctly, with each brushstroke in the proper order, was considered the sign of an educated person. People who wanted to work in government or business were required to learn calligraphy. A person had to pass a test that awarded the title of "calligrapher."

In addition to representing a word, brushstrokes could also show the writer's mood and personality. So calligraphy became more than simply writing to communicate. It was considered the highest form of art. People thought writing characters with a brush was much more impressive than painting pictures. Artists who painted but were not good at calligraphy were not considered good artists.

Calligraphers can use different types of scripts to make the characters, just as in Western writing people can use fun or formal alphabets for different purposes. For clear communication, calligraphers use the K'ai-shu script, and you will learn some K'ai-shu characters in this book. The different brushstrokes used to make the characters have names, such as the dragged dot, the bone stroke, and the vertical hook.

Artistic painters learn the K'ai-shu strokes of calligraphy because the same strokes are also used to paint traditional subjects. For example, the dragged dot is used to make the spikes of a pine cone, and variations of the bone stroke and the vertical hook stroke are used in painting bamboo.

This book teaches you the basic strokes of K'ai-shu calligraphy so that you can use the strokes in your paintings and write characters to describe your paintings. Learning the strokes also teaches you how to hold your hand and control the brush and paint.

Can you make these marks with a brush?

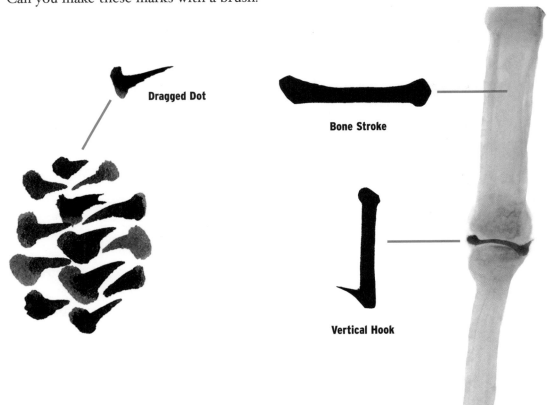

Dragged Dot

Bone Stroke

Vertical Hook

Principles of Chinese Characters

A *character* is a picture or "figure" made of brushstrokes. The Chinese language has no letters or alphabet but uses characters instead. Each character represents a word.

Two or more basic parts of characters can be squeezed together to form more complicated words.

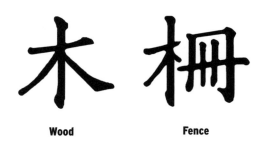

Wood Fence

One part in a complicated word is called a radical, meaning "root." The radical is used to look up the word in a dictionary.

Sometimes two characters written one above the other have a special meaning:

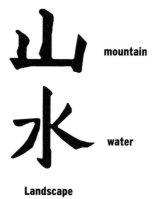

mountain

water

Landscape

The Soft Martial Art

Maybe you or your friends have studied a martial art like karate, aikido, or t'ai chi. You might be surprised, but painting with a brush is like doing a martial art. Why? Because in brush painting, too, you have to focus, especially when painting long strokes:

- First, you think about what step you're at in your painting;
- Then, you focus your thoughts on how you are about to move;
- You carefully take a breath and hold it;
- You make the move;
- Toward the end of the stroke, you let out your breath.

As you can see, brush painting is more than just swinging a brush across a piece of paper! It's about using the energy of life—called *ch'i* ("chee")—in a special way. You can learn to recognize and focus your *ch'i* energy when you paint. Of course, it takes a lot of practice to do it right. You need to make the brushstrokes

Learning to control the brush in different positions is part of the soft martial art of painting.

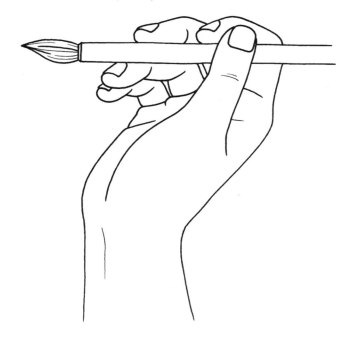

8

over and over again to remember the patterns. Learning to use the brush is a type of discipline that teaches patience, control, and respect for the art.

One of the hardest parts of brush painting is controlling a soft brush loaded with paint or ink. When you touch the brush to paper, especially rice paper, the liquid tends to ooze out in ways you don't want. You must learn how much liquid to load onto the brush and how to position your hand to make the desired stroke successfully. Unlike other types of painting, in Chinese brush painting there are few ways to cover your mistakes. Every stroke is important because it cannot be corrected or erased. Repeated practice and patience are required to achieve mastery. Yet, this practice makes you feel good when you do it well, like learning to play a piece on the piano or practicing shots in basketball. The result is an artwork of great simplicity and great power.

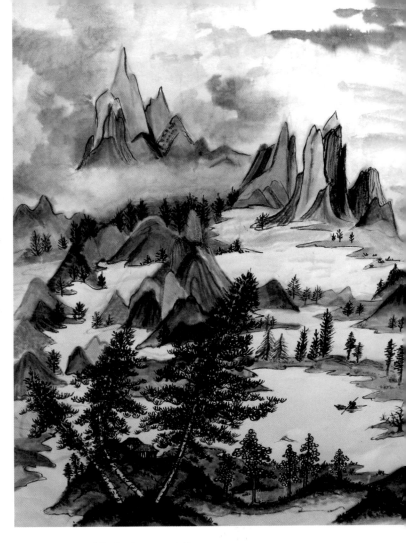

Humans are small in landscape paintings.

Inspired by Nature

Calligraphers throughout history have sometimes described their experiences in nature. In earliest times, they would fill large scrolls with calligraphy only. Their stories or poems might describe what they saw or did during a journey to the mountains or along a river.

Later, calligraphers began to add pictures to illustrate their stories. As these landscape paintings became more important and skillful, they were recognized as fine art. Landscape paintings convey the greatness of mountains and nature and show people as a small part of nature, rather than controlling it.

In addition to writing about and painting entire landscapes, calligraphers would also write poems about small natural objects, such as trees or flowers they admired, and illustrate them with paintings. Favorite traditional subjects are often grouped into sets. One set is called the Three Friends of Winter. The "friends" are bamboo, plum blossom, and pine—all plants that bloom or stay green in winter. Another group, orchid, bamboo, plum blossom, and chrysanthemum, is called the Four Gentlemen, because these plants were considered especially elegant. The classic subjects are admired for their appearance and symbolism. Each one is painted in a particular style that was refined and perfected over many years. In this book, you will learn how to paint some of these subjects, like orchid, bamboo, and pine.

9

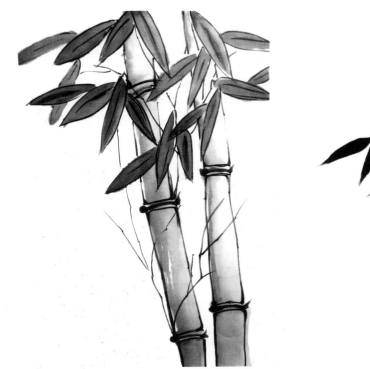

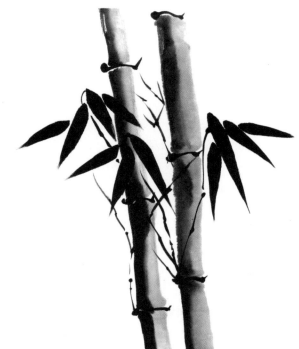

Boned and boneless bamboo

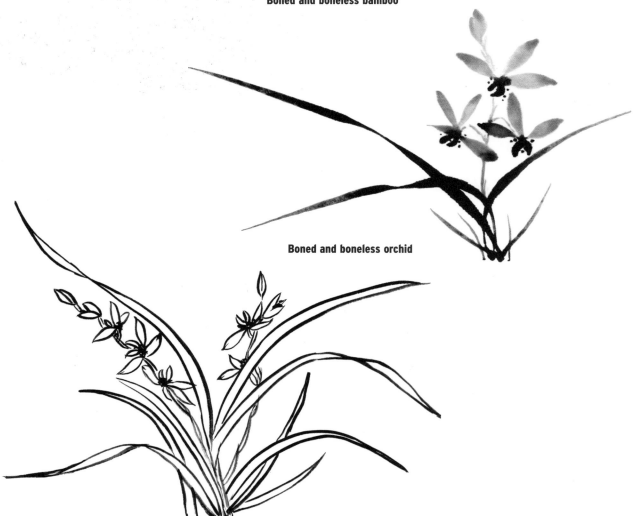

Boned and boneless orchid

10

Principles of Painting

Over the years, artists developed some general rules for brush painting.

Painting the Inner Spirit

One rule is that the artist should paint the inner spirit of the subject, not just its physical appearance. A painting is not meant to be a realistic photograph but an artistic vision of the subject.

Boned and Boneless

A traditional painting is done in one of two styles, *boned* or *boneless*.

- In the **boned** style, you paint outlines of the subject and then sometimes add gray shades. The boned style can look formal, stiff, and decorative.
- In the **boneless** style, you paint the subject with black or gray shades, with no outlines. The boneless style often uses bolder strokes, so it can appear more free and energetic.

This book teaches the boneless style because it requires more mastery of the brushstrokes.

Asymmetry—Odd Numbers Rule!

Symmetry in brush painting means that there are even numbers of things in the painting: 2 flowers, 4 stalks of bamboo, or 6 pine trees, for example. In a symmetrical painting, these objects are balanced on both sides of the painting, just as your right and left arms and legs are balanced on either side of your spine.

Asymmetry means that there are odd numbers of things in the painting: 3 orchid flowers, 5 pine wheels, and so on. More things are on one side of the painting than the other, but the objects balance each other because of their positions or different sizes.

In Chinese brush painting, asymmetry always rules! The painter may use 3, 5, or 7 objects. When painting an orchid, for example, the artist will paint one bud and two flowers, or three flowers, and five or seven leaves. A larger object can balance two or three smaller objects. To see how this works, count the flowers or leaves in the orchid paintings on the opposite page. Is there an odd or even number? Notice that some flowers or leaves are larger than the others. Although the orchid plant grows from a center, its flowers and leaves are not shown growing symmetrically on either side of the center.

Leaving Open Space

Now look at the empty spaces in these paintings. Part of the art of painting is deciding when to fill open space and when to leave it empty. Notice the triangles of open space around the orchid plants on the opposite page. Some painters like to leave a large amount of open space. It keeps the picture simple and creates a peaceful mood. Others prefer a picture with many objects and less open space. In the traditional painting style, the painter always leaves at least one large chunk of open space. Using asymmetry creates different sizes of open spaces in different parts of the painting.

Getting started

Collecting Your Materials

The picture below shows the basic materials you need for Chinese brush painting.

1. Table cover
2. Paint
3. Paint-mixing dishes
4. Paint-testing plate
5. Brush-washing containers
6. Water spoon
7. Brushes
8. Paper
9. Paper towel
10. Book holder
11. Book
12. Paper weights
13. Egg to train hand
14. Flat stone to train arm

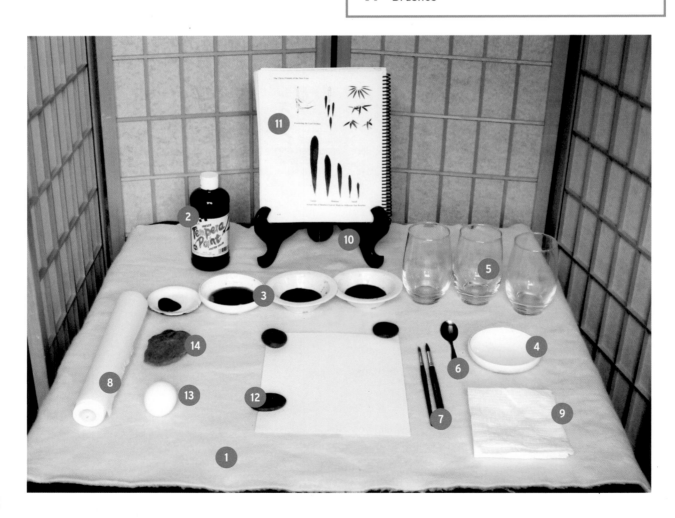

12

1. Table Cover

Use a piece of white felt to cover the table and absorb paint that could come through the paper and stain the table. Or use an old cotton sheet folded into several layers. The cover must be white because dark colors will show through the paper and make it hard for you to see the different gray shades of paint.

2. Paint

To start with, use a small bottle of black poster paint (tempera paint). Traditional Chinese painters use ink because it flows better than paint and dries shiny. But ink will leave permanent stains on hands, tables, and floors. After you have learned to control the brush and water, you can try the traditional Chinese way of grinding an inkstick on an inkstone to make a rich, black ink.

3. Paint-Mixing Dishes

Use four paint-mixing dishes and arrange them left to right in this order:

- A small dish to hold a few drops of concentrated black poster paint
- A large dish to hold a pale-to-medium mix
- A large dish to hold a medium-to-dark mix
- A large dish to hold a very dark mix

Paint, brushes, and paper can be purchased at your local art store or from artist supply companies on the Internet.

4. Paint-Testing Plate

A small white testing plate is useful to try out the color on the brush before making strokes or to mix other shades of gray. You could also use a folded paper towel to test the color, but a

Tips for the Workspace

- Allow at least 1 square yard (or meter) of table space so you can spread out the materials and have room to swing your arm and body when making brushstrokes.

- Sit in a high chair, so that your hands and elbows are above the table.

- When you are sitting, make sure you can look down at the work on the table and still have your feet flat on the floor and your body straight.

towel will soak up some of the water, which affects the stroke you are about to paint.

5. Brush-Washing Containers

You need the following containers for washing the brushes:

- A container for washing dirty brushes
- A container for rinsing dirty brushes
- A container for clean water

When you wash your brushes, swish them against the side of the jar so the hairs can separate and the water can clean them. Do not thump the brush up and down in the bottom of the jar! This will make the hairs break off from the handle.

6. Water Spoon

Use a teaspoon to spoon water into a paint-mixing dish.

7. Brushes

Bamboo brushes are best, but regular watercolor brushes made with natural hair also work well. Natural hair has an uneven surface that holds the paint. Synthetic brushes are smoother and

do not hold as much paint. You will need a large brush (#12 size watercolor brush) and a smaller one (#6 size). The bamboo brushes should be about those same sizes. For fine lines, it is useful to have a brush with only a few hairs, or you can use a round wooden toothpick instead.

8. Paper

You will do a lot of practice paintings. For these, use a package of newsprint either 9 x 12 or 10 x 15 inches. For your finished exercises, get a practice roll of rice paper 14 inches wide.

9. Paper Towel

Use a paper towel folded two times as a pad for testing paint colors and for getting rid of excess water after washing the brush. Towels are also handy for cleaning paint spills.

10. Book Holder

A book holder is convenient for keeping the lesson instructions in front of you as you paint. The holder should be large enough to hold the book firmly upright.

11. Book

Chinese painters work with screens in front of them. These face screens can be decorated and very beautiful, but that is not why they are used. Screens help artists focus on their paintings. For you, the book works like a screen. It keeps you from looking beyond the table at other things, so you can focus on your painting. According to Chinese thought, evil and distracting spirits travel in straight lines. When you place something in front of your

face, such as a face screen or book, the spirits cannot distract you while you are working.

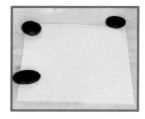

12. Paper Weights

When you cut sheets off a roll of rice paper, the edges tend to curl. Flat stone or metal weights help to keep the corners flat as you paint.

13. Egg to Train Hand

Holding an egg in your palm can train your hand and wrist to stay relaxed while you are holding the brush and keep your fingers from touching your palm. You can use a real egg, an artificial egg, or a crumpled piece of paper. Make sure that it fits the size of your palm.

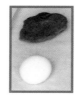

14. Flat Stone to Train Arm

A flat stone is used to train your arm to stay level when your wrist is bent upward to make a stroke.

Folder for Paintings

You will make many practice papers as you learn to use the brush. You don't have to keep all of them, but it's a good idea to keep the best paper from each exercise you do in this book as a record of your progress. You can safely store the good papers that you want to keep in a folder. It can be as simple as a folded piece of tagboard or two pieces of cardboard taped together.

Getting Ready to Paint

Set the Table

Cover the table with the felt pad or the cotton table cover and place a piece of newsprint on it. Anchor three corners of the paper with weights.

If you are right-handed, set up the items on the table as shown in the picture on page 12. If you are left-handed, move the water and mixing dishes to the left.

Prepare the Paint and Water

In 600 A.D., art schools in China tested the artist's ability to mix sixteen different shades of gray ranging from black to clear water. We will only be using about eight shades of gray. You make the gray shades by taking black paint and diluting it. *Dilute* means "add water."

Each time you get ready to paint, you need to prepare fresh paint and water.

1. Fill the water containers half full of water.
2. Into the smallest dish, pour a small amount of black paint. This will be used for mixing different shades of gray paint.

3. Using the teaspoon, put two teaspoons of water into each of the remaining three mixing dishes.
4. In a large dish, make a dark mix matching shade 2. Dip the tip of the brush into the dish of black paint to pick up paint. Transfer the brush to the mixing dish and swish the paint around well in the water to dilute the paint evenly. Test the color on the testing plate or on the paper towel. If it is not as dark as shade 2, add more black and mix and test again. Repeat the process until the test color matches shade 2.
5. Make a medium mix for shade 4 in the second large dish using the same method. For this shade, you need less paint for the same amount of water. Test the color against the chart.
6. In the last dish, use the same method to make a medium light mix to match shade 6.

You can use the testing dish to test the brush color and to mix small amounts of diluted gray. Use the following method to dilute the medium light mix into a lighter mix:

1. Take a brush full of clean water.
2. Scrape the water into the empty dish.
3. Dip the tip of the brush into the medium light mix dish.
4. Mix the medium mix into the clear water to make a very pale shade.

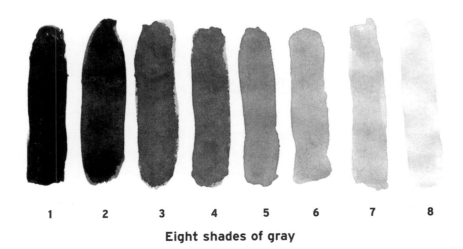

1 2 3 4 5 6 7 8

Eight shades of gray

Holding the Brush

Holding the brush in the Chinese style is important because it makes it easier to do the strokes.

1. Pick up the large brush with your thumb and your first finger.
2. Put your second finger next to your first on the brush. These two fingers are on the top of the brush.
3. Place your third finger under the brush and let your little finger sit next to it. This is position #1. This basic position of the brush allows you to paint in every direction.

Position #1 is also called the "vertical position." *Vertical* means that the brush is standing straight up. Most of the control of the brush comes from the second finger on top of the brush and the third finger beneath the brush.

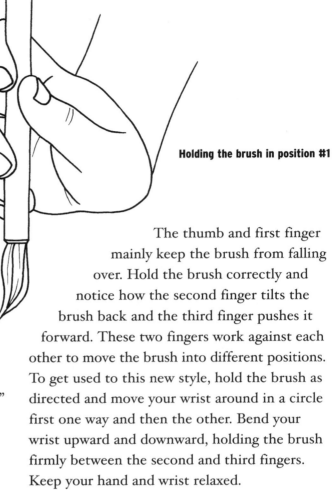

Holding the brush in position #1

The thumb and first finger mainly keep the brush from falling over. Hold the brush correctly and notice how the second finger tilts the brush back and the third finger pushes it forward. These two fingers work against each other to move the brush into different positions. To get used to this new style, hold the brush as directed and move your wrist around in a circle first one way and then the other. Bend your wrist upward and downward, holding the brush firmly between the second and third fingers. Keep your hand and wrist relaxed.

Exercise with an Egg

In China, children who are learning to use the brush hold a raw egg in their palm to keep the palm open and relaxed, so their hand does not get cramped. If they press too hard, the egg breaks and makes a mess, and they have to clean it up and start over.

1. Hold an egg in your palm as shown, or squeeze a large wad of paper tightly so it will fit in the palm of your hand.
2. Hold the brush correctly and move your wrist around in all directions, trying not to squeeze the egg.
3. In the basic position, you hold the brush in a vertical position with your wrist bent back and upward. Practice moving into this position ten times, until it feels comfortable.

Exercise with a Rock

Another exercise is to use a rock to keep your arm from rolling sideways when you bend the wrist upward. How good are you at balancing things on your wrist?

1. Place a flat rock on your arm where your wrist and arm meet. This area should stay level when your wrist bends up so the rock will not fall off.
2. Try putting the rock on your arm and moving your wrist up ten times without letting the rock fall off.

Five Positions

The basic position, position #1, is used the most. In addition to the basic position, painters use four other positions for holding the brush to make various strokes.

Positions #2 and #5 are horizontal positions. *Horizontal* means that the brush is held sideways. Positions #2 and

#5 make broad paint strokes. On the paper, the brushstroke has an even edge on the side where the hairs attach to the brush and a ragged edge on the other side, at the tip of the brush. Position #3 makes a thin-to-thick vertical stroke. Position #4 makes a thin-to-thick vertical stroke.

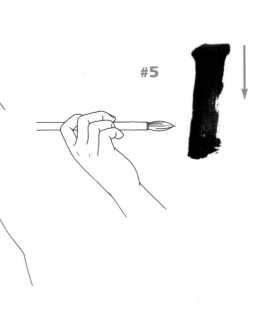

#3

#2

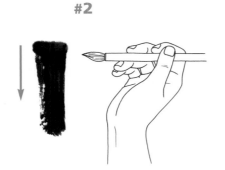

#5

#4

Positions #2 through #5 and the strokes they make

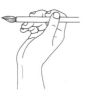 **Position #2:** Hold the brush in position #1 and then turn your hand to the far right so that the brush is pointing left. In this position, you can paint with the whole side of the brush. This position is used for painting bamboo and for large areas of gray color.

If you are left-handed, hold the brush with the left hand in position #1. Rotate the wrist to the left so the tip of the brush points to the right. This is position #2 with the left hand.

 Position #3: Hold the brush in position #1 and pull your arm back toward your body so that the brush tip is in front of your hand. This position makes a strong vertical stroke downward.

 Position #4: Hold the brush in position #1 and bend your hand forward and under, so the brush goes under your hand. As you push your arm away from your body, the brush makes a vertical stroke upward on the paper.

 Position #5: This position is most helpful in painting petals on flowers. Hold the brush in position #1 and turn your hand to the left so the brush hairs are sticking out at the far right. Make the stroke by moving your arm downward toward the body, leaving a wide stroke of paint.

Try each position of the brush. Practice moving your arm to make strokes in each position. Keep the tip of the brush in the center of the stroke. As you practice, you will learn what positions produce which kinds of paint strokes.

Pressure Test

This exercise helps you learn how hard you can press the brush against the paper. Using your finger and arm only, you can train your brain to make better strokes.

1. Put down the brush. Hold your hand in position #1, bend your wrist forward, and touch your first finger to the paper as if it were a paintbrush.
2. Move your arm slowly to the right about 5 inches, keeping your finger on the page. Feel the pressure of your finger on the paper. How hard did you press? Could you press more lightly and still feel the paper?
3. Try again using the same even pressure on the paper, only this time swing your arm smoothly downward.
4. Practice doing this exercise several times until your brain grasps the feel and motion.

Loading the Brush

The next step is learning to load the brush with paint.

1. Hold the brush in position #2 so the hairs are flat to the left.
2. Lay the whole side of the brush into the dish of dark paint and roll the brush with your thumb, forward and back, so that all the hairs pick up the paint.
3. Scrape the tip of the brush against the edge of the dish. This movement drops off any excess paint that could dribble on your work and spoil it. Get into the habit of doing this every time you load the brush.

washing the Brush

It is important to wash the brush properly to protect the hairs.

1. Swish the brush back and forth in the washing brush container.
2. Swish the brush again in the rinse water container.
3. Swish the brush again in clean water so the brush is clean.

Practicing strokes

Now that you have practiced holding the brush and moving it across the paper, you can start learning to control the paint and your arm movements by doing some simple strokes.

Dilution Grid

In this exercise, you make horizontal and vertical strokes, diluting the paint for each new pair. The goal is to practice smooth, even strokes and learn to make lighter and lighter gray shades.

1. Anchor a sheet of newsprint with the weights.
2. Load the brush with the dark mix. Test the shade on the plate to make sure it is very dark.

> **Remember:**
> Never thump the brush up and down in a container, hitting the bottom! That will break the hairs off the handle.

3. Hold the brush in position #1 with your hand to the far left of the paper. Swing your arm to the right, making a broad, straight stroke about 5 inches long.
4. With the same loaded brush and hand position at the far left, touch the top stroke at the left and move your arm downward to make a vertical line about 5 inches long.
5. To continue this exercise, dip about half the tip of the brush into clean water to dilute the paint slightly.
6. Go to the far left and make another horizontal stroke under the first one.
7. Without reloading the brush, make a second vertical stroke next to the first vertical.
8. Go back to the clean water and put a small amount of water on the brush.
9. Make a stroke sideways under the two top strokes across the page to the right. Notice how the paint is being diluted each time.
10. Move your hand to the left and make a stroke downward next to the other verticals.
11. Go back to the clean water and pick up one brushful to mix with the paint still in the brush.
12. Start at the left and stroke a line under the others above.
13. Make another vertical stroke next to the other two.
14. Continue diluting the paint and make two more sets of strokes to complete a grid.

Horizontal

Vertical

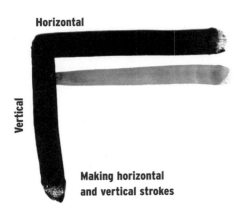

Making horizontal and vertical strokes

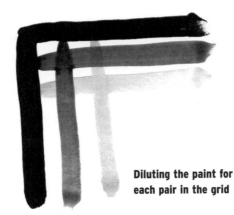

Diluting the paint for each pair in the grid

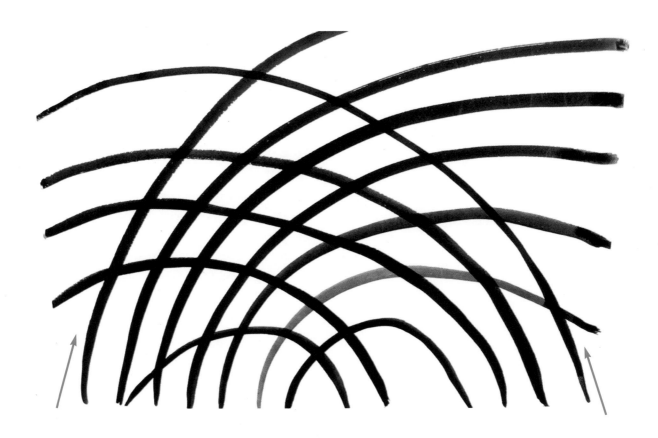

Now that you have learned horizontal and vertical strokes, you can move on to painting curves. Can you swing your arm in one direction to make a curve and then swing it in the other direction to make another curve?

Swinging Your Arm

Swinging your arm to make curves can help you to learn to paint orchid leaves and tall grasses. Now it is time to get some *ch'i* energy into the strokes. Before you start a stroke, take a breath, and then let out the breath while making the stroke. As a shortcut, we will use the code "TAB" for "Take A Breath" and the code "LOB" for "Let Out the Breath." So remember, every time you see our code word "TAB" below, you will Take A Breath, and when you see "LOB" you will Let Out the Breath.

1. Load a large brush with the dark mix and hold it in position #1.

2. Think and focus on what you need to do to make a beautiful stroke.

3. TAB, start at the bottom left of the page, swing your arm upward and to the right, and LOB during the last third of the stroke.

4. For the second stroke, TAB, start at the bottom to the right of the first stroke, swing your arm up and to the right and downward, and LOB as you taper off the stroke.

5. Continue making curved strokes that start at the bottom left, as shown in the example.

6. After you have completed strokes starting from the bottom left, make strokes from the bottom right to the upper left and downward, as shown in the example. Remember, TAB at the beginning and LOB as you taper off the stroke.

Making Thick and Thin Strokes

Making small strokes requires the same arm movements as curves and lines except the strokes are shorter and quicker. It is very important to learn to swing your arm only slightly to make short strokes. Learning to make the following thick and thin strokes is helpful for painting flowers.

1. Load a small brush with dark mix and hold your hand in position #1.
2. **Starting out thick:** Let the tip of the brush touch the paper, press and quickly lift a little, then press again and lift off. Notice the thick and thin stroke, which should be very short.

3. **Starting out thin:** Touch the paper with the brush tip and this time drag slightly, then press and lift a little quickly, then press again and taper off. This should make a different thin and thick stroke.

Making the Bone Stroke

Another stroke that is often used is the bone stroke. This too requires short arm swings. Why do you think it's called "bone"?

1. Load the small brush with the darkest paint mix and hold the brush in position #1.
2. Touch the tip of the brush to the paper, move your arm slightly to the left and down, then longer to the right, lifting the brush slightly, and then press and move your arm down to the left. Your movement is like a sideways figure eight. The tip of the brush covers its ends by coming back over the strokes. This is a very important way of painting with the tip of the brush. It hides both ends of the stroke.

Learning Calligraphy

People in the West hardly ever paint a word, frame it, and hang it on the wall in their house. It is very different in China, where calligraphy is considered the highest form of art. Some characters, each of which is a word, are very beautiful designs. Brush-painted characters are often framed or made into hanging scrolls and hung on the wall. Some art galleries have nothing but paintings of calligraphy. You too can make these beautiful works of art if you learn the basic strokes that are combined to make a character.

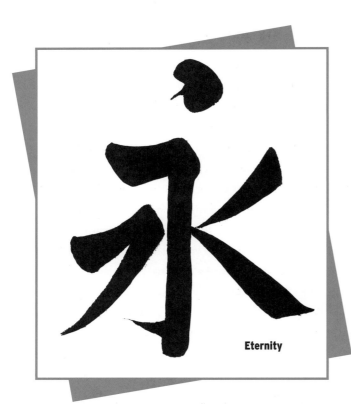

Eternity

Painting Basic Strokes

The basic strokes are very important. They are used not only to make words but also for flower petals, animal legs, and mountain peaks. All brushwork uses some form of these basic strokes.

The next page describes eight of the basic strokes and how to paint them. The Chinese like giving names to things, so each brushstroke has a name. The arrows show the direction the tip of the brush moves to make the stroke.

Tips for Learning the Basic Strokes

- Use the small brush and the dark mix.

- When loading the brush, roll the brush back and forth with your thumb to align the hairs.

- Use the tip of the brush and paint each of the strokes swinging your arm.

- Practice each basic stroke five times. Use quick moves. Make short strokes with energy.

1. Nail Stroke

Holding the brush vertical, push the tip slightly upward and then immediately downward, making an even-width stroke. Lift the brush and trail it off to make a point.

2. Descending Stroke

As in the nail stroke, push up, then down and slightly to the left. Lift the tip to make a point.

3. Trailing Stroke

With a vertical brush, move the tip down and to the right, pressing more to broaden the stroke. Roll the brush slightly away from you to make the heel. Lift it quickly to make a point.

4. Left Dot

Load the brush well and stroke the hairs to align them. With the brush vertical and the tip slightly to the left, lay the brush down, turn the tip up to the left, and lift it to make a blunt point.

5. Rightward Dot

Position the tip of the brush to the right, lay the tip down slightly, and press to the width desired. Lift the brush without making a point.

6. Pecking Dot

With your hand in position #2, lay the tip down, push the side of the brush to the lower left corner, and lift the brush quickly to make a point.

7. Bone Stroke

Stroke to the left, turn to the right, and then come back to the left. The action is similar to doing a horizontal figure eight.

8. Vertical Hook

Start out the same as the nail stroke. At the end, flip the tip to the left and upward.

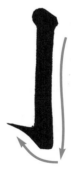

The strokes to make a character usually start at the top, move down to the left, then to the right, and finish at the bottom.

A well-known character that contains most of the basic strokes is the character for *eternity*, which means "forever and ever." Can you find the basic strokes in *eternity*? The character is shown on page 22. Look at the character and then look at the strokes above. Find the answer on page 24.

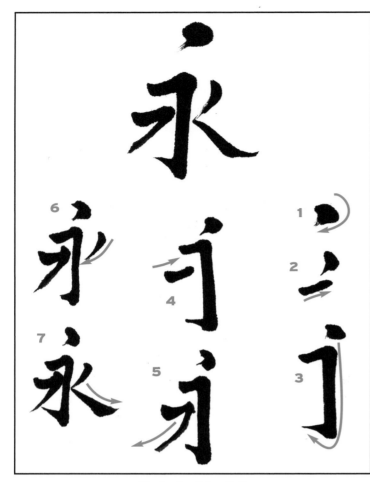

Strokes for "eternity"

The chart above shows the strokes for the character "eternity." Westerners write horizontally, starting words at the top left of the page and moving from left to right and downward. In China, the characters start at the top right of the page, move downward to the bottom of the page, and then start at the top again in the next column on the left. This is because, before paper was invented, people wrote on vertical strips of bamboo bound together into mats or books.

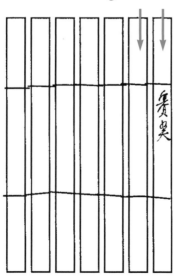

Writing from the top down and right to left on bamboo strips

In the same way, the directions for making a character also start in the upper right corner and move down, then go to the top of the next column on the left and move down, and so on.

			Start
19	13	7	1
20	14	8	2
21	15	9	3
22	16	10	4
23	17	11	5
24	18	12	6

Preparing Grids

Beginners often use a grid to help them place the strokes for a character correctly. To make a grid, you need a piece of paper, a ruler, and a pencil.

1. Using the ruler, make a square with each side 3 inches long.

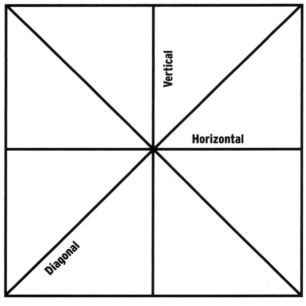

3-inch grid

2. Using the ruler, draw two diagonal lines to connect the corners.

3. Where these lines cross in the center, draw a vertical line up and down and a horizontal line across the box.

This grid will help you learn to place your calligraphy strokes. To get enough practice, you will need many copies of the grid. You can photocopy your hand-drawn page or use a computer to draw and print out multiple copies.

writing Numbers

It's fun to learn the numbers from one to ten in Chinese, plus a few other numbers. All these characters use combinations of the basic strokes. Practice each one several times, using the grid for help.

Number 1.
This character is just one bone stroke. Load the small brush with dark paint and hold your hand in position #1. Think about the bone stroke. It goes left and then right and then back left at the end. Notice where to place this stroke on the grid (across the horizontal line). Paint the stroke for number 1.

Number 2.
This character consists of two bone strokes. One is above the center horizontal line and shorter. The other is below the line and longer.

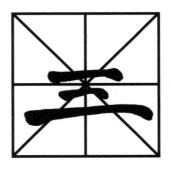

Number 3.
This character has three bone strokes. The top stroke is about where it was for number 2. The next stroke is short and below the center horizontal line. Paint these two strokes in. The last stroke is about the size of the character for number 1, but it is well below the center horizontal line.

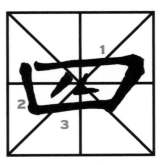

Number 4.
Here, the bone strokes make a box. The secret is to twist the brush when you turn the top right corner to make a flat edge.

1. Load the brush, start at the top left, press, lift, and drag to the right corner. Then roll the brush in your fingers to turn the corner and drag downward and stop. That is all one stroke.

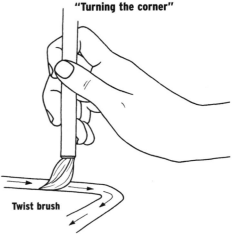

"Turning the corner"

Twist brush

2. Go to the top left again and make a vertical bone stroke and stop at the bottom. You now have two strokes hanging down.

3. Connect these with another bone stroke from left to right.

4. In the center of the rectangle toward the left, make a dragged dot to the left of the center vertical line. Next to it, put an L-shaped stroke on the center line.

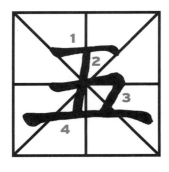

Number 5.

This character is made of more bone strokes. Notice that the center of the character is about in the center of the grid.

1. Load the brush with dark paint and make a bone stroke between the two diagonal lines about half way up from the center horizontal line.
2. Make a vertical line along the center vertical line down, ending about halfway to the bottom.
3. The center stroke is similar to the corner stroke for number 4. It goes to the right across the center horizontal line, turns the corner, and moves down. Paint this stroke and stop half way down.
4. Use the bone stroke to tie the verticals together. This is a long bone stroke in the middle of the bottom sections.

Number 6.

Notice that the bone stroke lies on the center horizontal line. Paint it with dark paint and your hand in position #1. The top dot lies on the center vertical line. The dragged dot on the left crosses the left diagonal line, while the long dot on the right lies on the right diagonal line.

Number 7.

The horizontal bone stroke lies above the center horizontal line. A new curved stroke crosses it. Try this stroke several times. It starts as a nail stroke, curves after it crosses the bone stroke, and ends with a quick move backward.

Number 8.

Make the trailing stroke to the right first. Then start the left descending stroke next to the top one, make a curve, and end the tail by rolling the brush up.

Number 9.

Notice that the left descending stroke is thicker. It starts next to the center vertical line and curves down over the diagonal line. The next stroke is like making the curve on number 4. Start like a bone stroke, curve up, and roll the brush to make the corner. Then curve in slightly and curve back to the right with a hook stroke. Since this is a new stroke, practice it several times.

Number 10.

This is an easy stroke, as you already know the nail stroke on the center vertical line and the bone stroke near the center horizontal line.

■ ■ ■

The numbers 11 through 19 use simple additions of the character for ten and a number. Eleven is "ten one," twelve is "ten two," and so on. 20 is "two ten." In numbers with more than two digits, the teen numbers require putting a "one" before the ten as a placeholder. 2010 would therefore be written as "two thousand zero one ten," and 2011 would be written as "two thousand zero one ten one."

If you want to write the year on your paintings, the following characters can help you. Larger numbers are written with more than one character. They are shown in two ways: written from left to right, as in Western style writing, and up to down, in the Chinese style. For your paintings, use the Chinese style and stack the numbers vertically going down the side of the page.

Number 1000. This number has the character for 1 and the character for 1000, which is made from a bone stroke, a blunt nail stroke, and a dragged dot.

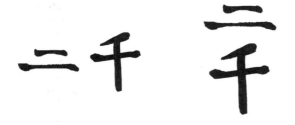

Number 2000. This number has the character for 2 and the character for 1000. It is read as "2 x 1000 = 2000."

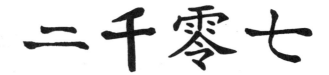

Number 2007. This number is made with the characters for 2000 followed by the characters 0 and 7. When a zero occurs in the middle of a large number, you need to write a zero, but only one, even if there are two or more zeroes in a row in the Western number. So 2007 in Chinese is "two thousand zero seven," where the character zero stands in for both the zeroes in the Western number. 2008 would be "two thousand zero eight," and 2009 would be "two thousand zero nine."

Painting Plant Characters

This book teaches you how to paint three of the most important plant subjects in Chinese painting: orchid, bamboo, and pine. When you finish a painting, you can add the character as a title of the painting. The characters use some of the same basic strokes you have already learned. You can practice the characters now, or you can wait until your painting is ready for a title.

"zero"

Number 0. A plain circle, like a Western zero, is sometimes used for zero. But the character for zero is used more often, especially in schools. Try your hand at making the zero character by following the sequence of strokes shown.

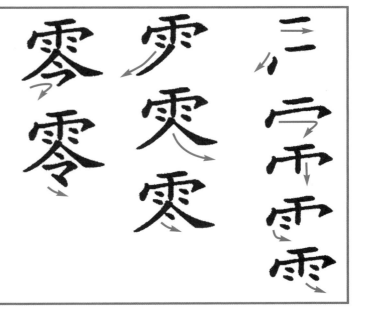

27

"Orchid"

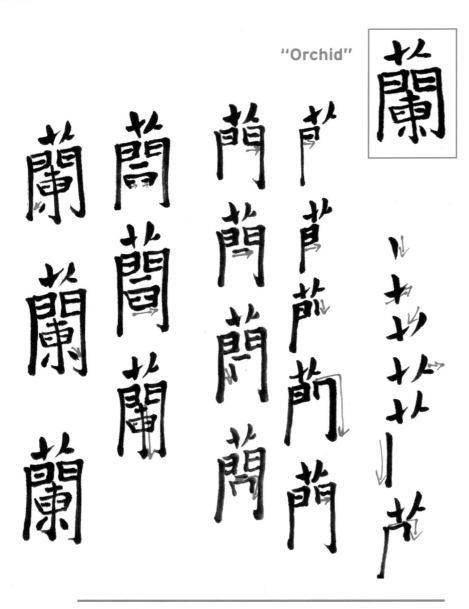

"Pine"

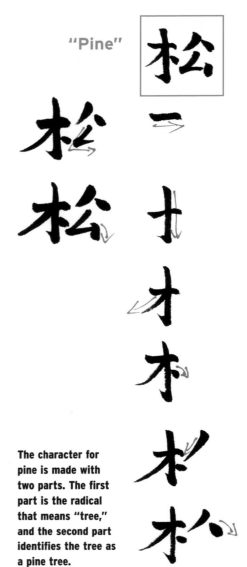

The character for pine is made with two parts. The first part is the radical that means "tree," and the second part identifies the tree as a pine tree.

"Bamboo"

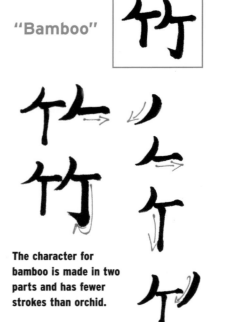

The character for bamboo is made in two parts and has fewer strokes than orchid.

Painting the Plant Characters

Try this paint-by-number game. Make each stroke in order, starting top right, working down, and then moving left. Look carefully at the character when you finish.

Look at Orchid. Can you see parts that look like two gates? These represent the gates to the Water Fairy's garden. She is the goddess of water. Inside her garden are water, rocks, orchids with a wonderful fragrance, and butterflies flitting around. These things are all represented in the character for orchid...can you see them?

Now look at Pine and Bamboo. What do you see?

Using Seals

Usually when an artist finishes a painting, he paints his name character, and under that he stamps a design with red paste ink. The design, and the block that makes it, is called a *seal*.

Seals can be round, square, oval, or any shape. The design of the person's name may have one or more characters, ancient pictographs, or a zodiac animal.

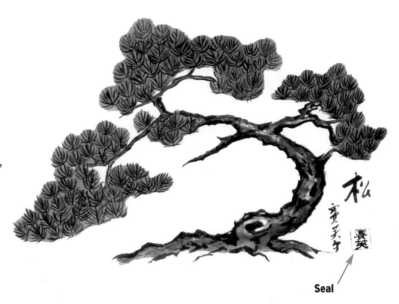

name. If a painting includes many characters describing it, as a landscape painting might, the characters go down the right side of the page or into another empty space to leave room for the artist's name and seal under it. If you use only the name character and the seal, they may go on the part of the page called the "back door." The back door is an open space that is opposite the main direction of the subject. For example, if the branches of the pine tree go mainly to the left, the back door would be low on the right.

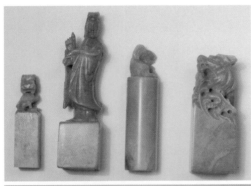

Seals

A fun thing to do is to make your own seal. You can use firm clay for a one-time seal, or clay that can be baked or fired for a seal you use over and over. Smooth a flat surface into the clay and use a pencil or fine point to carve your initials or a design in reverse. Paint the surface of the clay with black paint and press on paper. Try several times to get the right amount of paint to make a good print.

If you don't make a clay seal, you can use your thumbprint to identify your painting. Your thumbprint is very personal, and no one else has one like yours; this makes it good to use for your signature.

The placement of a seal is important. It usually goes under the characters for the artist's

Examples of seals

Painting orchid

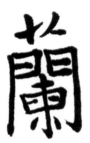

The orchid is one of the most important subjects in Chinese painting. It belongs to the set of classic subjects called the Four Gentlemen: orchid, bamboo, plum blossom, and chrysanthemum. Over many years, artists have developed a standard way of painting the orchid in black and white, with variations of gray.

The orchid is admired for its long, flowing leaves and graceful flower, which has a delicate fragrance. The plant therefore suggests an elegant lady performing a dance.

The orchid is a wildflower, not a garden flower. It grows near water and rocks. Its slender leaves, like blades of grass, bend as they grow longer. The blossoms are tucked in among the leaves and are smaller than most Western orchids.

Traditional Chinese painting shows two types of orchids. The Lan orchid has only one blossom on a stem. The Hsu orchid has a long stem with many blossoms along its length.

In this chapter, you will learn how to paint the Lan orchid in the boneless style. You have already learned to make orchid leaves, because they are nothing more than curved and twisted brushstrokes. Each orchid petal is also made with a single stroke. You define the shape of the petal by pressing and lifting the brush.

Deciding where to place the parts of the orchid on the paper is important. The goal is to create elegant and simple lines reaching out to the open spaces on the page. The leaves bend to the left and to the right and vary in size and direction. The strong, dark leaves protect the pale blossoms in between them.

The next page shows some examples of different orchid paintings that show variety in the leaves and petals.

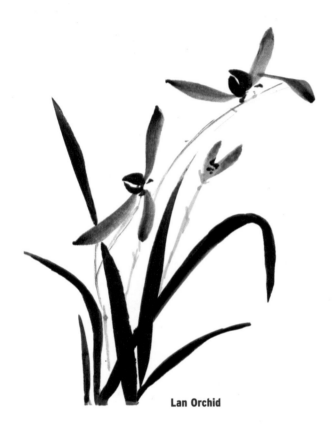

Lan Orchid

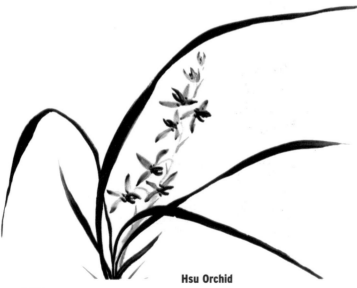

Hsu Orchid

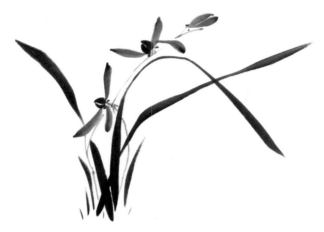

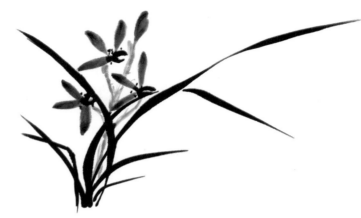

This grouping of two flowers and a bud has a simple leaf arrangement, with small leaves at the bottom. The open space created where two leaves cross is called a "Buddha's eye" because the space has the shape of an eye. This example shows a large Buddha's eye.

This composition has a long, graceful leaf arrangement reaching outward. The three blossoms are tucked in between the leaves. Here, the crossing leaves create a small Buddha's eye.

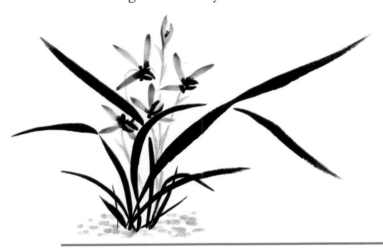

This arrangement of leaves, at left, is more balanced left and right. There are four blossoms and a bud (the fifth flower) in vertical position. It has both large leaves and small, anchored leaves at the root. The picture is also grounded by light strokes representing rocks.

Practicing orchid Leaves

Painting orchid leaves combines several strokes you practiced in the Getting Started chapter. Practice swinging your arm so you can make curved orchid leaves. This time, you also make thick and thin parts of a line. When the stroke is thin, it suggests that the leaf is twisted. Here is how you create this effect.

1. Load a large brush with the darkest paint mix and test it on the mixing plate to make sure that it is dark. Use hand position #1.

2. **Stroke 1.** Take a breath (TAB) and place the brush at the bottom center of the page. Swing your arm upward and to the right. As you go, lift the brush slightly to make the line thinner, press again to make the line thicker, and lift the brush to taper the end of the line as you let out the breath (LOB).

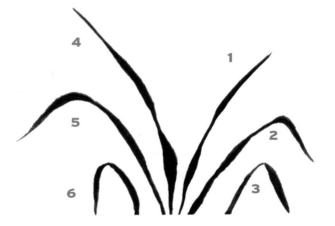

3. **Stroke 2.** Make the second stroke to the right of the first one using the same technique. This time, curve the line downward when you press after the first lift.

4. **Stroke 3.** For the third stroke to the right, make the leaf shorter and more tightly bent.

5. **Strokes 4-6.** Try doing the same types of strokes to the left. This may be more difficult if you are right-handed. Keep practicing swinging your arm, lifting, pressing, lifting again, and making the stroke look like a twisting orchid leaf.

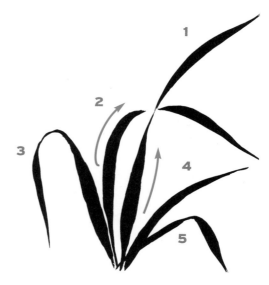

Two crossing leaves make a Buddha's eye

Painting orchid Leaves

The exercise for painting orchid leaves follows the principles for arranging orchid leaves. This example with five leaves includes a tall, main leaf (1), another large leaf crossing the dominant leaf making a Buddha's eye (2), a leaf curving to the left (3), and two other smaller leaves on the right, one curving upward (4) and one bending to the right and downward (5).

<div style="border: 1px solid black; padding: 10px;">

Principles for Arranging Orchid Leaves

■ Use an odd number of leaves, such as 5 or 7, and plan where flowers could fit between them. Allow for an odd number of flowers between the leaves, such as three flowers or two flowers and a bud. Some teachers say to paint the flowers first and then add leaves. However, for beginners, it is much easier to place the leaves correctly in the design first and then add flowers.

■ Make each leaf different in size and direction. One of the leaves should be longer and stronger as a main leaf. Smaller leaves can be made more curved.

■ Alternate leaves so that some go to the left and others go to the right.

■ You can let one leaf cross over another to make an opening between the leaves, a Buddha's eye.

</div>

1. Mix a very dark, almost black paint, which is traditional for orchid leaves.

2. Load a large brush with the very dark mix and roll the brush against the dish to align the hairs to make a nice point. Hold your hand in position #1.

3. **Leaf 1.** With the tip of the brush, start at the root of the plant and take a breath (TAB). Swing your arm up slightly to the right and press, lift, press and stroke upward and to the right, letting out the breath (LOB) as you lift and finish the stroke.

4. **Leaf 2.** Start at the root again, TAB, stroke upwards to the left of the first stroke, swing your arm to the right, lifting as you cross over the first stroke, press again as you bend the stroke downward, and LOB as you lift the brush.

5. **Leaf 3.** Reload the brush with dark paint. Start near the root, TAB, press and swing your arm upward and to the left, lifting to make a thin stroke, then curve downward with a broader brush and LOB as you lift the brush.

6. **Leaf 4.** Start at the root, TAB, and swing up and to the right slightly as you let out the breath.

7. **Leaf 5.** Start near the root, TAB, swing your arm up to the right, press and lift, curve your arm and brush, press and move downward, and lift as you let out the breath (LOB).

8. Try painting this plant again to improve your leaves.

Painting orchid flowers

The flower has three types of parts:

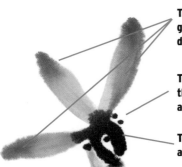

Three long, pale petals growing out in different directions

Three pollen-bearing stems at the bottom called stamens and represented by three dots

Two dark, small petals at the center

An orchid flower is usually painted with five petals: two short, dark ones and three long, lighter ones that all meet at the center of the flower. The three stamens at the center are called "the heart" because their shape resembles the calligraphy for the word "heart."

Painting the Short, Dark Petals

These two petals are the beginning of the flower, and the heart is where the two bottoms come together. The stroke for these petals is a press-and-lift stroke.

1. Mix very dark paint, load the large brush and roll it to align the hairs, and hold your hand in position #1.
2. **Stroke 1.** Place the tip of the brush on the paper, press slightly, curve your arm to the left and down and then to the right and lift. This should make a dark comma.
3. **Stroke 2.** Starting slightly above the other stroke, make the curve, swing right and then left and down, making another comma opposite the first one.

Painting the Long, Light Petals

The long petals are painted from the outer edge inward toward the center.

1. Prepare a medium light mix of paint and test the color on the mixing plate.
2. Load the large brush with the medium light mix, tap off the excess, dip the tip only into dark paint, and tap off the excess. Hold your hand in position #1.
3. Touch the tip of the brush to the paper, press and drag slightly, and lift, making a long thin tail that joins the heart. This should make a petal with a dark tip and light elsewhere.

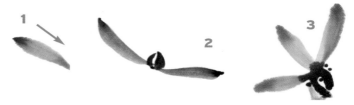

One, two, and three petals

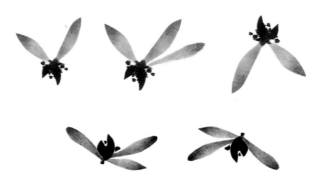

Variations in flower positions

Painting All Five Petals

Notice in the picture above the different positions of the flowers. Depending on where the two dark petals are placed, right or left, facing up or down, the flowers will look different from each other.

Practice painting all five petals together, as in the following example.

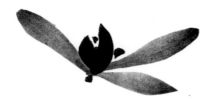

1. Start with the two dark commas at the top.
2. Change to medium light paint, tip the brush in the dark paint, and make one stroke from slightly upper left to the center bottom of the commas.
3. Make a stroke from the upper right toward the center.
4. Make the third stroke, which can be lower and at an angle but still connects to the center with the long thin stroke.

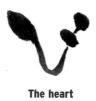

The heart

Painting the Stamens (the Heart)

The stamens at the center are painted with the calligraphy strokes for the character "heart." They consist of three dots, a long dragged one and two small connected ones. The dragged dot part wraps around the short, dark petals, so it often does not show in the painting.

1. Load the small brush with very dark paint and tap off the excess. Hold the brush in position #1.
2. Touch and press the brush tip to make the left-hand dot, lift and drag the brush to make the curving tail, and then lift and press twice to make the two right dots.

Painting the Stems

The stem of a flower has a series of short branches at the top and a long stem down to the root with a graceful curve.

1. Load a small brush with the medium light paint and hold your hand in position #1.
2. Paint a short curve from the bottom of the flower.
3. At the end of the curve, paint another short curve in the opposite direction.
4. At the end of the second curve, paint another curve in the opposite direction and run it all the way down to the root of the plant.

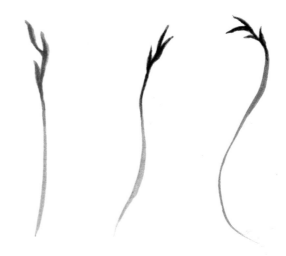

The stems can be relatively straight or more curving, depending on the location of the flower in relation to the leaves.

Arranging Leaves, Flowers, Stems

Now you can put the different parts together to paint a full orchid plant.

1. Plan an orchid design. You might use the arrangement of leaves that you have already practiced.

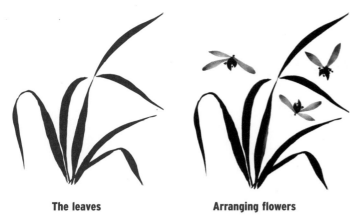

The leaves **Arranging flowers**

2. Paint the leaves.

3. Plan and paint an odd number of flowers between the leaves, such as in the composition above.

4. For the stems, load the small brush with medium light paint and hold your hand in position #1.

5. Paint the stems for the blossoms:

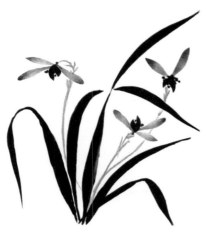

Adding stems

- For the left blossom, start at the top, curve up, and come down to the root.
- For the right top blossom, start at the heart and make a nice curve to the left down to the root.
- For the right bottom blossom, start at the heart and swing around and down in a curve to the root.

Try other designs, leaf arrangements, and flower angles of your own. Remember to use odd numbers! It's a game of three of one thing and five of another.

Painting a Bud

Where you have a small space between leaves, you can put in a bud instead of a full flower. An orchid bud looks like a flower with shorter petals.

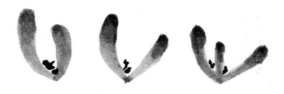

1. Load the large brush with the medium light mix of paint.

2. Paint the bud as two pale commas, using the same strokes as for the short petals.

Usually the Hsu orchid, where all the blossoms are on one stem, has a bud on the stem near the root, as it is the last to bloom. Above are some variations on buds, at different degrees of opening.

Using Rice Paper

After you have painted all the parts that make up the orchid plant on newsprint, practice on rice paper. See how the paint oozes out differently on the rice paper. Rice paper has a smooth side and a rough side. You will find that it is easier to control the paint on the smooth side. Remember to tap the brush on a paper towel to remove excess water before making a stroke on rice paper.

Painting Bamboo

Bamboo is the most familiar subject in Chinese culture and art. It belongs to two sets of classic subjects: the Four Gentlemen and also the Three Friends of Winter, which are bamboo, plum blossom, and pine. Bamboo expresses the will to survive. Its stalks resist strong winds; they bend but never break. The wind whistling through bamboo is called the music of the gods.

This chapter follows the traditional style of using black and grays to paint bamboo. The strokes have been perfected over many centuries until they show the true spirit of bamboo. This style began when some talented old master painters showed their art. Their paintings were so admired that other artists copied them because they thought they showed the best way to paint bamboo.

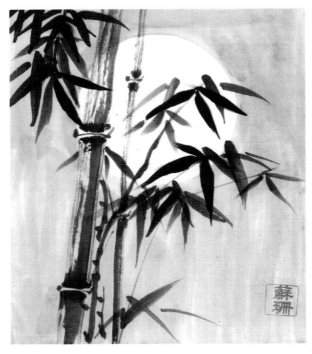

Bamboo and moon

Brush Styles

Bamboo can be painted in either boned or boneless styles or in a mix of the two. The favorite style, which we will use, is to do the entire painting in boneless style.

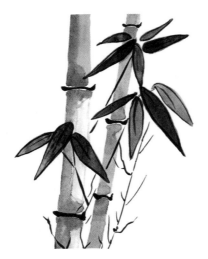

Boned leaves, boneless stalks

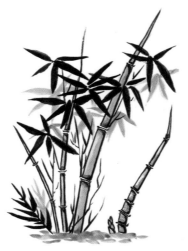

Boned stalks, boneless leaves

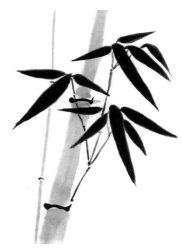

Boneless stalks and leaves

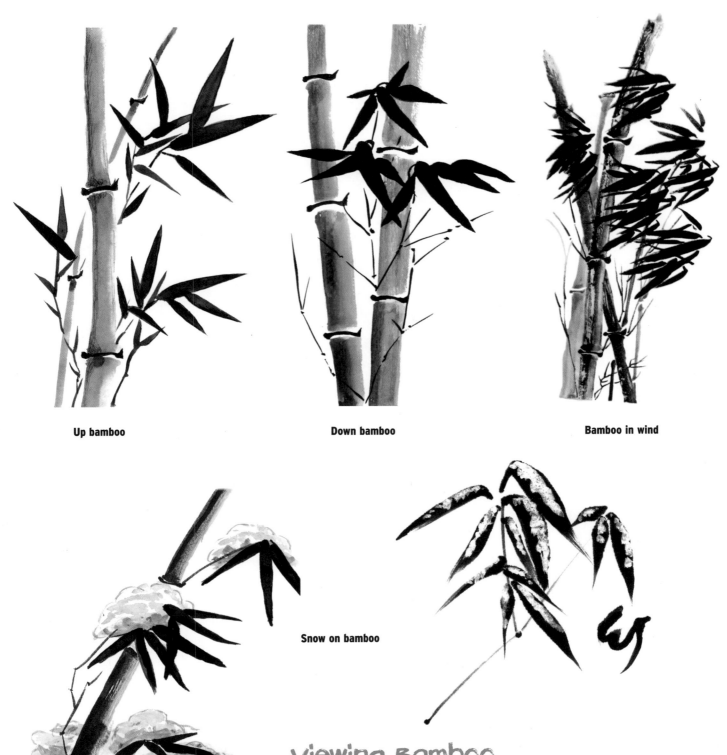

Up bamboo

Down bamboo

Bamboo in wind

Snow on bamboo

Viewing Bamboo

There are many species of bamboo and over 100 varieties.
Leaves can grow upward from the stalk or downward in
clusters off small branches. The most traditional style is the
one with clusters of leaves. Bamboo is painted blowing in the
wind, in front of the moon, or with snow on its leaves.
When it rains, bamboo leaves curl up to let the rain drip off.

37

Painting Bamboo Stalks

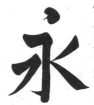

The strokes used for painting bamboo are some of the same basic strokes you learned earlier in the character for "eternity."

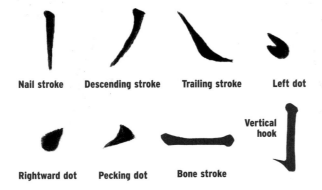

Nail stroke **Descending stroke** **Trailing stroke** **Left dot**

Vertical hook

Rightward dot **Pecking dot** **Bone stroke**

The bamboo stalk is made mainly by using the basic bone stroke in a vertical direction. The Chinese name of the bone stroke means "go forward and go back," which is what the brush is doing.

Go back to the chart of basic strokes in the calligraphy chapter and review how the strokes are made. Make believe your finger is a brush making the bone stroke. Move it to the left and stop; move right and stop; and move left. Notice how the stroke ends are covered.

To paint the bamboo stalk, you make the bone stroke with the side of the brush going up and down rather than left to right. Again, practice with your finger as the brush. This time push down, then up 4 inches, and then swing your arm down again. The feel of swinging your arm down and up in a short space of time is important.

When you paint the bone stroke for the bamboo stalk, hold your hand in position #2, shown right. This means you rotate your hand to the right so the hairs of the brush are on the paper and the tip is pointing left. With a dry brush, lay the hairs down on the paper and drag it toward your body. Try to keep the heel of the brush (where the hairs join the handle) down on the paper. This will help to make a straight line on the right side of the bamboo stalk.

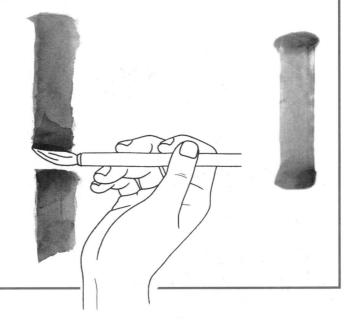

Painting Bamboo Stalk Sections

Now try to paint a section of bamboo stalk with the bone stroke using brush and paint. The stalk sections are painted starting from the bottom of the page and moving upwards.

1. Mix a large dish of medium light mix. Test it on the mixing plate.
2. Load the brush by rolling all of the hairs forward and back in the dish so that every hair has paint.
3. Rotate your hand to the right and press the whole brush down, especially the heel of the brush. Push down with your arm, stop, push up 4 inches, stop, and push your arm and brush down slightly to end the stroke. Notice that you have made a darker area at the top and bottom of the section. This is the growth ring on the bamboo stalk.
4. Stop and look at the stroke. Does it have a straight edge on the right side? Is the width of the stroke even? Try it again many times.

To make an entire stalk, start with the bottom section and keep adding sections above it. The sections of the bamboo are painted the way they grow. The sections at the bottom are closer together, and as the plant gets taller, each section is a little longer. So paint each section slightly longer than the one below it.

1. To make the lowest section, load the brush and lay it down on the paper 2 inches above where the ground would be for the bamboo. Push up with your arm, stop, push down 3 inches and off the page. Notice the darker area at the top of the section and the lighter area at the bottom where the stalk grows in the ground.
2. Make the middle section as in the steps you followed above, with growth rings at the top and bottom.
3. To make the top section, load the brush and lay it down slightly above the middle section. Push down, stop, and then push up 5 inches and off the page. Notice that you have made a darker area at the bottom of the section and a lighter area at the top.

To make a thinner stalk on the bamboo, rotate your hand to the right but lift the heel of the brush a little off the paper, so you use less of the brush.

1. Load the brush and try making a stroke with the heel slightly off the page. Did you make a narrower stalk this time?
2. Try this several times, trying to keep the same pressure on the paper.
3. Experiment with making thinner bamboo stalks by raising the heel more and using less and less brush.

4. Try making a thinner stalk for the top section or for a younger bamboo stalk.

In making a design for bamboo, use thick and thin stalks and short and tall stalks as well as different kinds of leaf clusters.

Painting Joint Rings

In between the sections is a joint ring. When bamboo is bending in the wind, the bending takes place only at the joint ring. Bamboo sections do not bend. They are rigid and are always painted straight. Notice that the beginnings and ends of the sections are darker. This is the area where the joint rings grow.

The joint ring is painted with one of the basic strokes, only shortened and turned sideways. The shape looks like the vertical hook.

Vertical hook and joint ring

1. Load the small brush with dark mix and hold your hand in position #1.

2. Press the tip of the brush up and to the left, stop, drag your arm down very slightly, swing to the right 1 inch, stop, and press and lift quickly upward, making a small hook.

3. Practice the joint ring stroke many times.

The joint ring is an important stroke and must fit into the space between the two stalk sections. Learn to make this stroke in many sizes to fit different size stalk sections.

Painting Branches

The small branches that hold the leaves grow off the joint area. They grow on opposite sides up the stalk, first one side and then the other. It helps to know where the leaf clusters will be placed before painting in the branches.

As shown in the examples here, very small branches can be painted with simple strokes of the small brush. Other branches can be made with the bone stroke and the tip of the brush to show the joints in the branches.

The rule is to have no more than two branches coming from the same joint. The branches grow off only one side of a joint. The side changes from one joint to the next. For example, the stalk here has branches on the right side for the lower joint and branches on the left side for the upper joint.

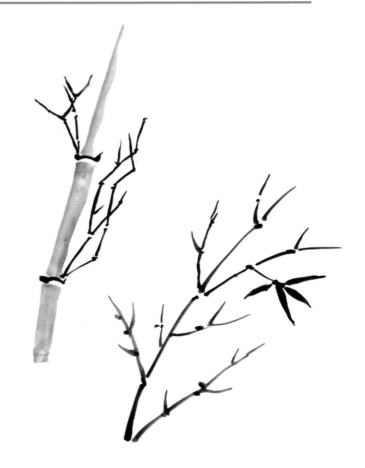

Painting Leaves

Bamboo leaves are very important in a painting. The viewer notices them first because they are so dark.

Leaf Patterns

The patterns of bamboo leaf clusters have been studied and copied for centuries.

Clusters usually have three, four, or five leaves, but near the top of the stalk they may have only one or two leaves. Usually, one leaf is larger. It is called the "host," and the smaller leaves around it are called "guests."

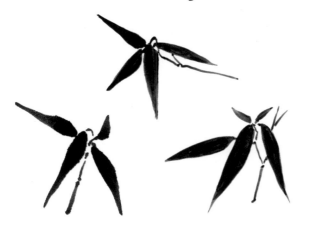

In every pattern, each leaf points in a different direction. The leaves connect to the same branch and fan out from that point. In the painting below, notice how the leaves point in different directions. Never paint all

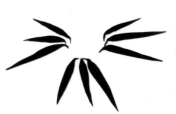

the leaves in one direction or make them the same size or length.

The bamboo leaf is similar to the shape of the orchid petal, only a little fatter and evenly balanced on each side of the center vein.

The widest part of the leaf stroke is made after it touches the paper, just before lifting the

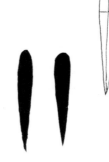

brush. Leaf ends should always be straight and pointed. This happens better when you take a breath before the stroke and let it out as the stroke finishes.

Painting a Leaf

1. Practice first using your finger instead of the brush. Touch your finger to the paper, press, drag slightly and slowly, and lift it little by little, keeping the tip of the finger in the center of the stroke.

2. Load the large brush in the dark mix, rolling it forward and back in the dish so that all the hairs have paint. Tap off the excess and hold your hand in position #1.

3. Touch the brush tip to the paper, TAB, drag slightly, press, lift little by little, LOB and make a point.

4. Practice this many times until the stroke is balanced with a straight point, keeping the tip of the brush in the center.

Painting Leaf Clusters

Now that you have the feel of the brush for a straight stroke, try making strokes going left and right, as in the examples below.

After you can make strokes right and left, plan the leaves to make a cluster. No two leaves should be exactly the same size or point in the same direction. The spaces between the leaves should also be different. The sequence for placing the leaves is the same as in calligraphy: Do the center, then the left, then the right, then left and right again.

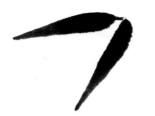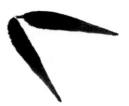

1. Load the large brush and tap off the excess.

2. **Stroke 1.** Touch the brush near the center of the leaf area of the painting, press, drag, and lift little by little, moving slightly to the right so the stroke will not be vertical. This is the host leaf, the largest one in the cluster.

3. **Stroke 2.** Make a second, smaller stroke toward the left, leaving a wide space from the first stroke.

4. **Stroke 3.** Make the third stroke to the right of the main one. Start it close to the main and go to the right.

5. **Stroke 4.** Make the fourth stroke start very near the main and swing to the left, almost horizontal.

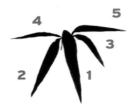

6. **Stroke 5.** If there is a fifth stroke, make it come off the top of the cluster as if it is going straight out the back of the cluster of leaves.

Try making different clusters of leaves your own way so that the final picture will have variety. Decide on three different clusters for your picture.

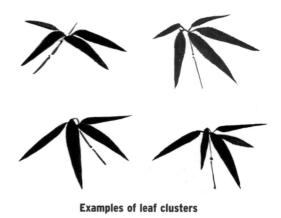

Examples of leaf clusters

other Ways to Paint Leaves

After you have practiced painting the basic stalks and leaf clusters, you can try painting them in different ways.

Painting Cross-Over Leaves

In painting orchid, the Buddha's eye adds interest to the leaf design. In painting bamboo, crossing a leaf over another within a bamboo leaf cluster also adds interest. Practice painting cross-over leaf patterns like the ones shown below. Do not paint the cross-over leaf until the lower leaf is slightly dry. Otherwise, both leaves will blur.

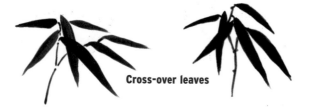

Cross-over leaves

Painting Many-Layer Clusters

A cluster can seem to have many layers going back in space. To create this effect, you paint a layer of larger leaves in front, a layer of smaller leaves behind that, and a layer of even smaller leaves behind or above that. Leaves painted with lighter paint also seem to be further back in space than the strong, dark leaves at the front.

Whenever you paint many layers of leaves, paint the large leaves first, let them dry slightly, paint the smaller leaves, let them dry slightly; and last, paint the smallest leaves at the back.

Can you find the three layers?

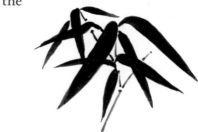

Triple-layer cluster

Painting Dry Brush Stalks

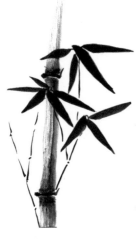

One way to paint bamboo stalks is to use a dry brush with dark paint to make the bone strokes. The dry brush makes stripes that represent the fibers of the bamboo. The white areas defined by the strokes are called "flying white."

Dry brush bamboo

1. Load the large brush with the medium mix. Lay the brush against the paper towel to get out some of the moisture. Stroke the brush on the towel to see if it is still too wet.
2. Start the vertical bone stroke for a stalk section to see if you can produce flying white.
3. Keep practicing to get the right amount of moisture to create the effect.

Painting Rounded Stalks

Shading one side of the bamboo stalk makes it look rounded.

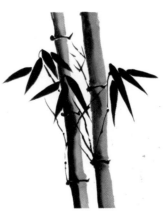

1. Load the brush with medium light mix and tip the end of the brush into the dark mix.
2. Stroke a section of a bamboo stalk. Notice the dark area on the left side, which makes the bamboo stalk look more rounded.
3. You can also make a second, narrower stalk by holding your arm up slightly and using only a portion of the brush.

Adding Leaf Clusters to Stalks

Now that you have practiced leaf clusters, you can add them to stalks.

1. Paint one or more bamboo stalks.
2. Plan where you will place each of your three clusters.
3. Paint the leaf clusters. Start with the top left clusters and then do the right clusters. Be careful not to smear the strokes with your hand.
4. Add the branches that attach the clusters to the bamboo stalk at the joint. Load the small brush with dark paint and roll it to make a fine point.
5. Pick a joint on one side and paint a thin line toward the center of the cluster to make a small branch.
6. Add other branches from a joint to a cluster as needed. Remember to put no more than two branches from the same joint and to change sides with each joint.
7. Practice different designs of leaf clusters attached to stalks and branches.

Painting Bamboo on Rice Paper

When your practice painting is the best you can do, go ahead and paint the whole design on rice paper. Practice using less water on the brush by tapping it on a paper towel to take out some of the water. This action will keep the paint from running too much on the paper and making a fuzzy blob. Remember to paint on the smooth side of the rice paper for best results.

Painting Pine

Pine belongs to the set of classic subjects called the Three Friends of Winter: bamboo, plum blossom, and pine. Because it is an evergreen, it is considered a symbol of longevity, sturdiness, and endurance. It blows in the wind, its branches break, and the trunk blows over. But it still survives for years with scars that show its history. The Chinese call the tree "a gentleman of character." Pine is useful for fuel, furniture, baskets, and food in the form of pine nuts. Its soot is used to make inksticks.

A pine tree usually grows symmetrically unless branches are hit by lightning or break. But the side that gets the most sun grows better and may have longer and fuller needles. The Chinese like to paint pines in an asymmetric way that has been copied over many years. The bark looks like the scales on a fish. The technique for painting it is called *bark scales*.

Pines can be painted with snow on the branches or with pine cones hanging down. Most painters show the pine as tall and stately, with its branches reaching out in all directions. These branches can vary in size and direction, with some of the needles hanging among the pine cones.

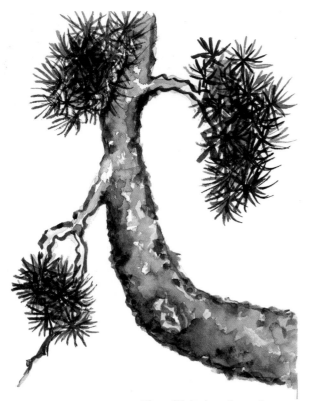

Pine with bark scales and scars

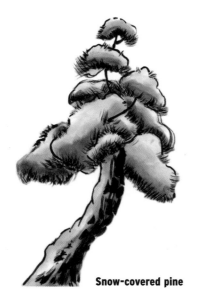

Snow-covered pine

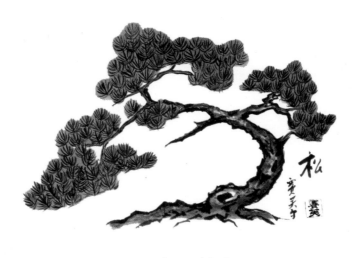

Asymmetric pine

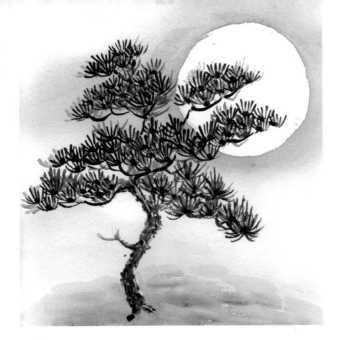

Pine in moonlight

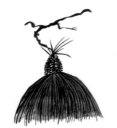

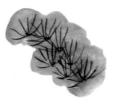

Needles like ballerina skirts **Wheels of needles**

Pine is also painted standing in front of the moon. Some species of pine have clusters of long needles hanging down, like ballerina skirts. Others have needles growing along the tips of the branches. Others have needle clusters like half wheels. There are usually 3, 5, or 7 branches with clusters of needles.

The artist usually paints branches growing off the parts of the trunk that are lumpy. Knots in the trunk are part of where the branch grows out. Branches are thicker near the trunk and get thinner as they grow outward.

A branch is painted not with a straight line but with the familiar press, drag, and lift stroke. You typically plan where you would place five clusters of needles before painting any branches. Plan how the wheels of needles overlap to make a cluster. Make each cluster a different size. Usually the larger clusters are at the bottom unless they overlap to make a large cluster up higher.

Painting the Trunk

There are several ways to start the pine tree trunk. You can try each way and then decide which is best for you. The brushstrokes for pine are similar to those you have tried before, with slight changes.

Press-and-Lift Method

Practice with your finger at the bottom of the page instead of a brush. Press down, drag it upward a little, and lift a little; then press again, drag up, and lift. Try this several times so your arm will move smoothly between press, drag, lift, and press. This is a very important stroke that is used in many ways.

1. Load the large brush with the dark paint mix and roll it forward and back so the hairs are filled with paint. Rotate your hand to the right into position #2.

2. Starting at the bottom of the page, press, drag up a bit, lift, press, drag up, lift, and so on.

3. Work your way up the page, making areas of thick and thin and getting smaller overall as you go up the paper.

4. Wash the brush, dip it in clean water, and run a line of clear water on each side of the dragged line so some of the color oozes out and makes a soft edge. Do this several times, trying to make it look like a tree trunk.

Zigzag and Wet Method

1. Load the large brush with dark paint and hold your hand in position #1.
2. Make a zigzag line up the page moving to the right and then to the left to make a crooked tree.
3. Quickly add water to the brush and run a line along the right side of the zigzag.
4. Wash the brush and add clean water to the other side of the zigzag.
5. This should make a crooked trunk with dark and light areas. Where it is light, use the small brush and dark paint and outline circles to represent scales on the bark areas.

Graded Zigzag Method

1. Load the large brush with dark paint, blot off the tip on a paper towel, and add water to the tip.
2. Rotate your hand to the right into position #2, lay the brush down on the paper, and push the brush to the left and then back to the center as you move upward slightly to the right. This action makes a zigzag across the page with a line that is light on the left side and darker on the right side.
3. Lift the brush slightly as you move your arm up the page so the trunk will get narrower, and end with a lift to make a tip.

Go back and try all of these ways to make a pine tree trunk. Remember that this is a painting, and your trunk may not look like a pine tree trunk you see out the window. Decide which way you prefer to paint your trunk, and then paint it that way.

Painting Pine Needle Wheels

The pine needle wheel is painted with a center dot to which all the needle strokes go.

1. Load the brush with a very dark paint. Roll the hairs back and forth to make a fine point.
2. Use position #1 and make a dot. This will be the center of the wheel.
3. Directly above the dot, make a vertical stroke down to the dot. This is a pine needle.
4. Touching the paper lightly and swinging your arm at an even pace, move around the dot from the left to the far right, making strokes towards the dot in the middle. This is the top wheel of needles.
5. Below it and slightly to the left, make a dot for the next wheel center.
6. Stroke the brush from the left side to the dot, and continue around the half-circle, ending the wheel on the far right.

Principles of Pine Needle Wheels

- A cluster usually contains 5, 7, or 9 wheels.
- Try to keep your arm pressure on the paper the same so the strokes will be even.
- Make a row of dots gradually moving down the page. Paint the strokes to each dot. The strokes will overlap slightly as the wheels slope to the right and downward.
- Plan where the dots will go to make the next diagonal line under the top row. This should make a cluster sloping downward.
- Clusters at the bottom of the tree are larger and have more wheels. The ones towards the top of the tree are smaller.
- Practice making the wheels slope left and right.

7. To the left and slightly below the wheel, make a dot for the next wheel. Make strokes toward the dot. They should overlap slightly as they go diagonally toward the left and downward.

8. Do five of these wheels, as shown.

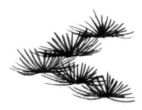

Painting the Full Pine Tree

Now that you have tried out three ways to make pine tree trunks, choose one that you want to use to paint a weather-beaten tree.

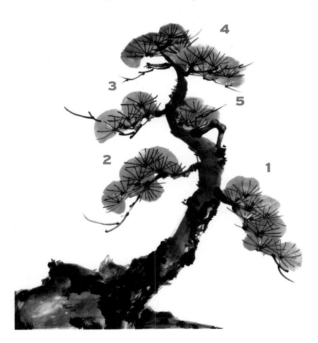

1. Load the brush as described for the trunk method you want to use.

2. Start at the left bottom of the page and paint the trunk upward as in the example, using your chosen method. The trunk should move a longer distance to the right, then shorter to the left, then even shorter to the right, and end with a very narrow stroke to the left. This makes a more interesting tree than a straight, vertical one.

3. Add the darker bark scales.

4. Plan the placement of clusters of needles:

 Cluster 1. A cluster sloping to the right and downward low down on the right side of the trunk.

 Cluster 2. A cluster going downward and to the left higher on the trunk on the left side. These two large clusters are the main green parts of the tree.

 Cluster 3. A cluster sloping to the left and downward.

 Cluster 4. A cluster that will cover the top of the tree, then slope to the right and downward.

 Cluster 5. A small cluster at the bend in the trunk.

 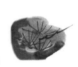

5. Paint in the clusters you have planned as you did in the wheels exercise.

6. Observe where the branches might connect from the bottom of each cluster to the tree trunk. The connections are made by using the press-and-lift stroke.

7. To paint the branches, load a small brush with dark paint. Make a press stroke on the trunk, lift slightly, drag, and press, lifting to trail off in a thin stroke under the bottom of the cluster. Where the branch connects to the trunk, the press stroke is heavy. Near the top of the tree, the branch stroke is smaller, but it still makes a thin line under the cluster.

8. To finish off the tree, use light paint on the small brush and stroke a half circle of paint like a gray cloud around each wheel in the cluster. This holds the cluster together as a unit.

If you did a good job painting pine on newsprint, try doing it on rice paper. Remember to use the smooth side of the rice paper so that your pine needles do not blur.

Painting Tree Arrangements

Trees are sometimes painted in groups, since that is the way they usually grow. When painting more than one tree, a common approach is to place a large, dominant tree as a host and smaller ones around it as its guests, which are less important. To make the arrangement of a host and two guest trees, decide the type of trunks you prefer.

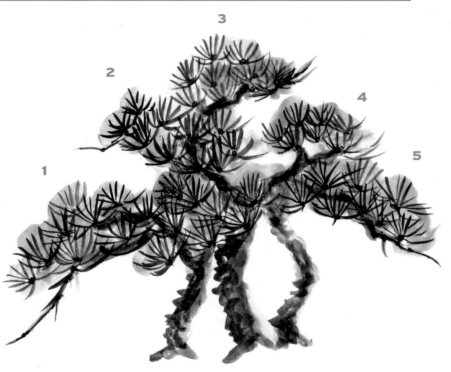

A host and two guest trees

Painting Trunks for a Tree Group

1. Load the large brush as described for the trunk method you want to use.

2. **Left guest tree: trunk and branch 1.** Start at the bottom at the left and press, drag, and press with the brush, sloping the trunk slightly to the left for a few inches, and stop. This will be the left guest.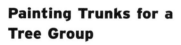

3. **Host tree: trunk and branches 2, 3, 4.** To make the host tree in the middle, reload the brush and make a zigzag stroke wider than the first trunk, moving slightly to the left and 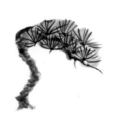 then to the right, for a taller trunk than the left one, and stop.

4. **Right guest tree: trunk and branch 5.** To make the right guest, reload the brush, press and drag left, then right, and then left near the center trunk. Stop here to allow space for the clusters of needles attached to the trunks.

Painting Wheels for a Tree Group

1. **Branch 1.** As usual, start at the left, with the left guest, and plan a large cluster of needles that will slope to the left.

2. Use the small brush with very dark paint and mark where the center dots will be for the top row of wheels.

3. Paint the strokes to the dots, overlapping diagonally as they go left and downward.

4. **Branch 5.** Move to the right guest and paint a cluster moving to the right and downward, but make it higher than the cluster on the left. Keep it asymmetrical.

5. **Branch 4.** The open area in the center of the page is for the host tree. Paint in the wheels for the top row sloping downward to the right.

6. **Branch 3.** The left end of the trunk can have a large cluster. Mark the dots and paint about nine wheels.

7. **Branch 2.** Directly above this cluster and slightly to the right, mark dots for a rounded-up top cluster moving to the right and up. Paint in these clusters.

8. Notice where you have open spaces for the branches.

Painting Branches for a Tree Group

Because trees grow in all four directions, some of the branches are not seen.

1. To complete this grouping of trees, load the small brush with dark paint.

2. Start with a small line under the left cluster and make a press-and-lift stroke going right. Attach this to the trunk of the left tree.

3. Above the cluster on the host tree, make a mark suggesting that the needles hide the rest of the branch.

4. Make another stroke to the right, connecting to the middle group of clusters.

5. Further toward the top of the host tree, mark a small branch to meet the top group of wheels.

6. Move to the right, make a thin line, press, and then continue under the cluster of wheels on the far right.

Painting over Wheels for a Needle Group

1. When all of the clusters seem to be attached, move to the small brush and medium light mix.

2. Swing your arm and make gray circles around each of the wheels starting at the far left, working up and down the middle and up the right side. Work from left to right across the page so your hand does not get into the wet paint.

3. Check every wheel to make sure it looks more solid than just some radiating lines.

Keep this exercise and use it to do a large one on rice paper.

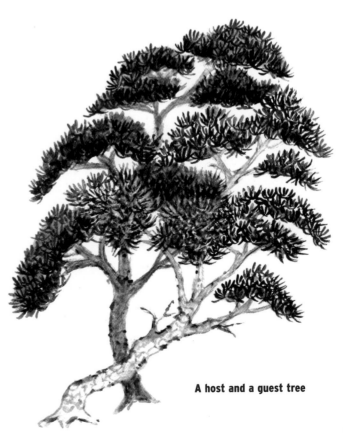

A host and a guest tree

Painting Pine cones

Many artists paint pine trees with cones hanging down from the branches. Pine cones usually hang from strong branches, and many times there are two cones near each other.

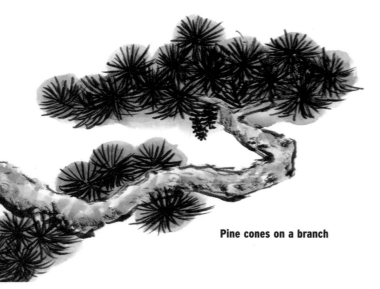

Pine cones on a branch

The cones are painted with the basic stroke made from the dragged dot.

1. Use the small brush loaded with dark paint and your hand slightly in position #2, so the brush can be dragged.
2. Start with the brush tip toward the left, press, drag a bit to the right, and lift. This should make a triangular-shaped stroke. Under this stroke, make four others, one under the other, down the page. This will be the spine of the cone.
3. Now reload the brush, start at the top row to the right of the spine, and make a dragged stroke from the right toward the spine.

Under this row, make three more dragged dots toward the spine. The cone is usually fatter in the middle and gets smaller and more pointed at the bottom.

4. Go to the left side of the center row, start at the top, and make the dragged dot from left to right so the point is toward the spine. Move the dots closer to the spine as they get to the bottom.
5. To end the cone, paint two dragged dots moving up from the bottom to meet the spine.
6. Go back and look at the spacing of the dots. If you see open spaces between the outer row and the spine, add a dragged dot to fill in the space.
7. Load a small brush with light mix.
8. Add a light color in the center of the cone to make it look solid.

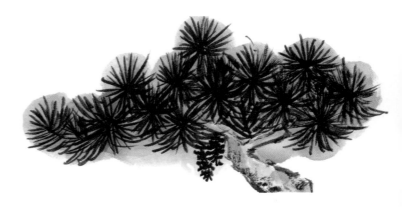

Take one of the pine tree examples and use it as a branch. From a twig connected to the main branch, paint a pine cone, leave a little space, and paint another pine cone a little lower than the first. Around the top of the twig, add a few wheels of needles.

Designs
with
Insects
and Birds

Chinese painters like to add insects and birds to their paintings. Moving creatures add interest to flower and tree paintings in the same way that people add interest to landscapes.

Painting a Butterfly near an Orchid

It's fun to paint butterflies. Butterflies are attracted to the fragrance of wild orchid flowers and are often seen flying around or landing on the blossoms.

Painting Butterfly Wings

Butterfly wings are painted by using the basic dragged dot stroke in different positions. The butterfly is shown in flight at an angle, so its wings are not symmetrical. Asymmetry rules once again!

1. Load the large brush with medium light paint.
2. To make the large upper left wing, think about the dragged dot that you have learned. Place the side of the brush at an angle over the paper where the top left of the wing will be. Press, drag, and lift quickly to make the narrow area where the wing attaches to the body.
3. For the upper right wing, use the tip of the brush. Roll the brush sideways on the plate to make the hairs roll into a point. Start the stroke at the upper right tip of the wing. Press and lift quickly to make the point meet at the point of the left wing.
4. To make the lower right wing, put the tip of the brush at the center where the other lines meet. Press lightly and lay the heel of the brush down to make a dot for the wing.
5. Once again, roll the brush to make a point.

On the left lower side, start the stroke at the center and lay down a short, dragged dot. You should have two large upper wings and two smaller ones at the bottom.

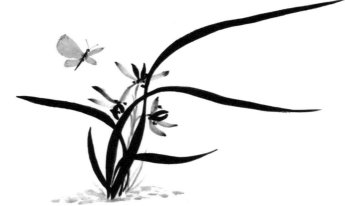

Painting the Butterfly Body

The body of the butterfly is shown at an angle because of the position of the right wings. The body is a long oval with two eye dots at the top. Between the eyes are two small antennae. Along the sides of the body are three sets of legs.

1. Load the small brush with medium light paint. Roll the brush to make a point.
2. Start painting at the head and make a single stroke similar to the nail stroke for the body.
3. Load the small brush with dark paint. Roll the brush to make a point.
4. Make a single stroke to darken the body below the head.
5. Instead of using the small brush to paint the details of the body, you can use a toothpick dipped into dark paint.
6. Start at the end of one antenna and make a dot. Reload and make a curved line to the head. Reload and make a second antenna in the same way.
7. The legs of the butterfly are close to the body and are very small. Again, use a toothpick to make three sets of legs that bend on each side of the body.
8. Add the tiny dots on the edges of the wings. It is easier to paint them in carefully with the toothpick held vertically.
9. Practice this butterfly several times.

Now you are ready to try to add it to a design.

Adding a Butterfly to an Orchid Design

Plan a new design with orchid leaves and flowers. Leave a space among the flowers to place a butterfly in flight.

Notice that the butterfly is about the same size as an orchid blossom, which is not very big. The butterfly helps to define the scale of the orchid plant.

1. Paint the orchid design on practice paper.
2. Add the butterfly to the design.
3. Keep practicing the combination until you like the results.

Now you can go to the rice paper. Paint the orchid design and butterfly. Remember to paint on the smooth side of the rice paper. You've made another masterpiece!

Painting an orchid with a snail

It's fun to see a snail balancing on an orchid leaf. You can imagine that it was on the ground and crawled up the leaf. Its weight causes the leaf to bend down even more.

Painting a Snail

The shell of the snail is represented by a light spiral. The body of the snail is a long

oval at the bottom that curves up on the right to make a wider area for the head. As with the butterfly, there is a dot for the eye and two antennae.

1. Load the large brush with light paint.
2. Using your arm, make a large filled circle to represent the shell of the snail.
3. While the circle is still wet, load the small brush with dark paint and make a curving line from the center of the shell outward. Let the dark paint ooze out into the lighter paint to make soft edges. Practice this many times.
4. Using the small brush loaded with dark paint, make the long oval for the body of the snail. Press at the right to make a wider area for the head, drag to the left, and lift to make a point at the tail. Add a small curve at the lower front of the body to show the muscle the snail uses to move forward.
5. As with the butterfly, use a toothpick loaded with dark paint to make the dots and lines for the two antennae.

Adding a Snail to an Orchid Design

Plan a new orchid design with one leaf on the right curving up and then down where the snail is crawling. This design should be easy to do because you have done it before.

1. Paint the orchid design.
2. Add the snail to the leaf on the design.

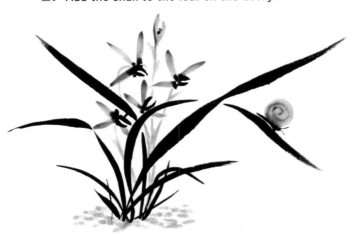

3. Keep practicing the combination until you like the results.

Paint the design on rice paper to become one of the rice paper masterpieces in your folder. Remember to use the smooth side of the rice paper.

Painting a Bird on a Pine Branch

Chinese people are fond of birds. They keep pet birds in cages and take the cages for walks in the park to meet other people with birds in cages. Birds are also painted in the wild flying in the air or sitting on a branch.

Painting a Bird

The Chinese paint many kinds of birds. You will learn to paint a simple kind of singing bird. Does he look like he's singing? How can you tell?

1. Load the small brush with dark paint.
2. Painting a bird usually begins with the beak. Make a small press-and-lift stroke from left to right for the upper part of the beak. Make another stroke touching the first one beneath it and about the same size.
3. Notice that the head of the bird is an oval, and its body is shaped like an egg. Judge how large the body and head should be to match the beak. You cannot draw on rice paper or erase on it, but you can sketch your plan by making a mark with your fingernail on the paper. Make a slight indentation on the paper the size you think the head and body should be.

53

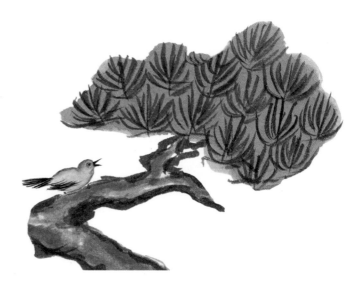

4. Load the large brush with medium light paint. Test it on the plate to see that it is not too dark.

5. Paint the outline of the body and head by following the fingernail line. Leave a white circle for the eye area and fill in the whole body of the bird.

6. When the head and body area has dried a little, load the small brush with dark paint and make a dark dot for the eye. Leave a white area around the dot. Using a toothpick, make a thin dark line around the white eye area.

7. Load the large brush with dark paint.

8. To make the tail feathers, stroke from the bottom of the body downward and to the left with a long stroke. Make each feather a different length.

9. On the left side of the bird, about one third of the way up, make several feather strokes with the large brush to represent wing feathers.

10. Load the small brush with dark paint. The leg is attached to the body at the bottom. Paint the leg almost as you would paint the joint ring on a bamboo stalk. End the stroke differently by making two finger-like forms that attach to the tree branch. Behind the joint, add another small leg.

11. Practice this bird several times before attempting to add it to a design.

Painting a Pine Branch Design

Go back to the lesson on pine trees and plan a branch with wheels of needles and a space where a bird might sit.

1. Load the large brush with dark paint. Tap it on a paper towel and dip the tip into water.

2. Using this double-loaded brush, press and lift and zigzag to make a branch that moves up and down and up again and splits to make two small branches.

3. Load the small brush with dark paint and roll the brush to make a point.

4. Remember how you put a dot in the center of the wheel of needles. Place some dots in diagonal lines going up and down along the branches.

5. For each wheel, paint needles with even lines going toward the dot.

6. Load the large brush with light paint.

7. To fill in between the needles, swing your arm from left to right over each wheel using the whole brush.

Adding a Bird to a Pine Branch

When you have painted the wheels of needles, plan where on the branch a bird might sit. Notice in this example that the bird is sitting on a branch and is facing toward the right. Its legs are tucked under it and do not show.

1. Paint the pine branch design.

2. Plan how large the bird should be compared to the size of the wheels of needles. The bird should be at least as large as a wheel.

3. Paint the bird in the design.

4. Keep practicing the combination until you like your results.

5. Paint the design on rice paper to make another masterpiece for your folder. Remember to paint on the smooth side of the paper to prevent the pine needles from blurring.

Painting Landscape

山水

The Chinese word for landscape is made of the characters for "mountain" and "water," since mountains and water are often found in landscapes.

Ming dynasty artists included three different viewpoints in their mountain scenes. In the painting to the left, we are looking *down* at the man crossing the bridge.

As we move up the painting, the houses and trees are at eye level.

Beyond the trees, in the mist, we look *up* at the mountains, which makes them look very tall and monumental.

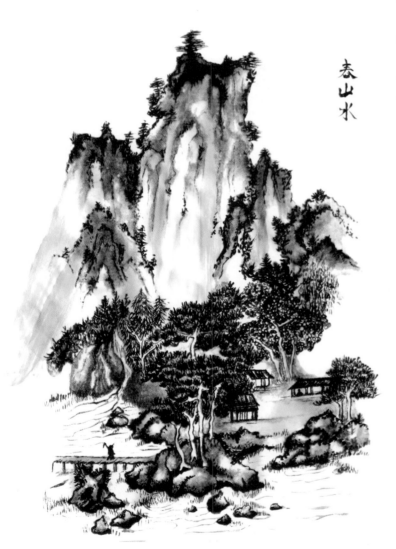

Principles of Landscape Painting

When they paint traditional landscapes, artists follow specific principles:

- Always include some form of water. This could be mist, fog, rain, snow, river, waterfall, lake, or ocean.

- Include three levels of viewing the scene:

 1. Up on a cliff or in the sky looking down on the scene from above

 2. Looking straight out at eye level

 3. Looking up at the mountain from below

- Include evidence of humans in nature, such as a path, a house, a bridge, a boat, or people. They are always very small in relation to the grandeur of nature.

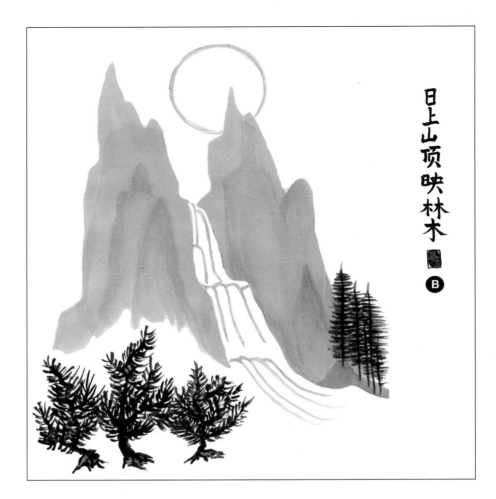

日上山頂映林木

B

Painting a Mountain Scene

We'll learn more about landscape by trying the painting above. This landscape painting shows two mountains with a waterfall flowing out from between them. The sun is rising from behind one mountain and shining down on the trees below. When you have finished the painting, you can add calligraphy that means, "The sun rises over the mountain and shines on the forest of trees."

If you prefer, you could do a painting with simpler mountains, such as one of the mountain scenes below.

Painting the Mountains

Look at the picture with the two mountains on page 56. The brushstroke that paints the first mountain starts up the left side and moves over the top and down. Use your finger like a brush to follow the line. Move to the other mountain and follow its outline.

1. Load the large brush with medium black paint and roll the tip to make a fine point. Use a vertical brush in position #1.

2. Swing your arm up and follow the line up the mountain and down the other side.

3. Immediately dip the brush in water and run it along the inner edge of the line forming the mountain, both up and down. The water should blend the color toward the center.

4. Reload the brush, paint the outline of the second mountain, and quickly add a water line to blend the color toward the center.

5. Even after you have added the water, there should still be a plain paper area in the center of each mountain. Fill the large brush with water and make a wet line of water inside the first mountain line, but closer to the center.

6. Now load the brush with medium paint, and make a paint line in the middle of the water line so the color oozes out in both directions, making a new, small mountain line in front of the large outlined mountain already painted.

7. Move to the second mountain and wet the inner mountain area. Load the brush with color and make a soft oozing line suggesting the mountain in front. There should be a small space between the two mountains to allow space for the waterfall.

Painting the Sun

The sun and the moon are often included in landscape paintings to add interest. They are a part of nature that landscape painters want to record. The sun and the moon are usually painted when they are at full size and shown as circles.

Enso is a Japanese word that means "circle." To make a sun for your painting, you need to be able to make ensos.

Ensos

1. Touch your finger lightly to the paper at the left.

2. Swing your arm upward, then to the right, down, and back to the beginning spot, completing the circle. Feel the swing of your arm, and try to make it an even swing.

3. Focus on the beginning spot and, as you swing your arm around, keep your eye on it to aim the brush toward the end of the stroke. Practice this swing several times. This exercise tests your ability to concentrate on the task at hand.

To paint the sun rising over the mountain in your landscape picture, you need to make a perfect circle.

1. Load the small brush with medium paint, hold your hand in position #1 and the brush in a vertical position, and focus on what you plan to do.
2. Place the tip of the brush on the paper and start the swing right away, going up and to the right, down the other side, and back to the beginning spot, using your whole body and arm.
3. With practice, you can make perfect circles. Practice making smaller and smaller ensos, as they are usually small in paintings.
4. When you think you can do a good circle most of the time, try adding the sun to your mountain picture.

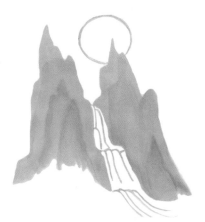

Painting the Waterfall

A waterfall adds an interesting element to a landscape. In this scene, a waterfall flows between the two mountains. To paint it correctly, you need a fine point on the brush.

1. Load the brush with medium dark paint and roll it forward and back to make a point.
2. To make it easier to make fine lines, you can use your left hand as a support. This works only for short fine lines where you do not need to move your arm or hand across the paper. You move the brush only slightly with your fingers. Lay your left hand flat on the table under your right hand as it holds the pointed brush vertically. Practice making fine lines in this way before continuing.
3. Lower the tip of the brush until it barely touches the paper. Using only the tip, move your fingers slightly to make the top three downward lines of the waterfall.
4. Then move your fingers slightly a short distance to the right for the shelf.
5. Still holding your right hand over your left, make several longer strokes downward. Be careful not to let them run together.
6. Add another set of strokes at the bottom.
7. If you have difficulty making thin lines, use a toothpick dipped in medium paint.

Painting Trees in the Distance

Distant trees in a landscape are painted with simple strokes. Often, several types of trees with different textures are painted to add interest.

Start with the trunks of the trees, and then add different strokes for branches to show different types of trees.

1. Load a small brush with dark paint and hold it in position #1.
2. Begin a stroke at the top of the tree trunk and pull downward a few inches. Repeat this seven times, making each trunk longer or shorter than the last one and leaving different spaces between the trunks.

Try making different varieties of trees by painting different types of branches. These are examples of trees one might see off in the distance in your landscape.

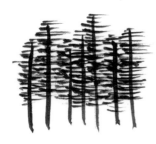

Horizontal branches.
Paint in horizontal lines by swinging your arm from left to right a short distance. Make the lines at the top shorter and have them get wider toward the bottom of the trunk.

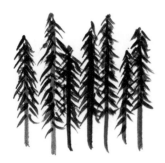

Curved branches.
Make more vertical trunks, varying the height and the space between them as you did before. This time, add short strokes at an angle and slightly downward connecting to the trunks.

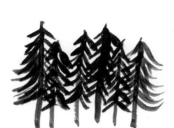

Diagonal branches.
Roll the brush to a nice point and hold it vertically. Make more trunk strokes, and this time add longer strokes sloping out to the left and then out to the right of the trunks.

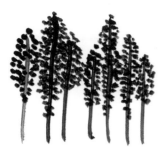

Dotted branches.
Add even dots along the trunk, making more where the tree gets fatter and fewer where the tree has fewer leaves at the bottom.

Painting the Middle Space Trees

Middle space trees are closer to the viewer than trees in the distance.

This type of tree can be a point of interest at the bottom of the mountain. The tree will be more anchored if you add some roots growing up out of the ground. For the main part of the painting, use larger trees, such as those painted in the pine lesson. Make the branches overlap, and make each tree different.

For the mountain scene, paint a cluster of three trees as shown, using what you learned in the pine chapter.

1. Put a host tree in the center. Make the trunk zig to the left and zag to the right, with branches coming off in several places.
2. Left of the host tree, paint a smaller trunk and again zigzag to make it more interesting.
3. Right of the host tree, make a guest trunk that is different from the other trunks.
4. For the leaves, use straight lines as on the pine tree.

Painting on Rice Paper

After practicing this landscape on newsprint, try doing it on rice paper. Remember to paint on the smooth side of the rice paper so the little strokes do not blur.

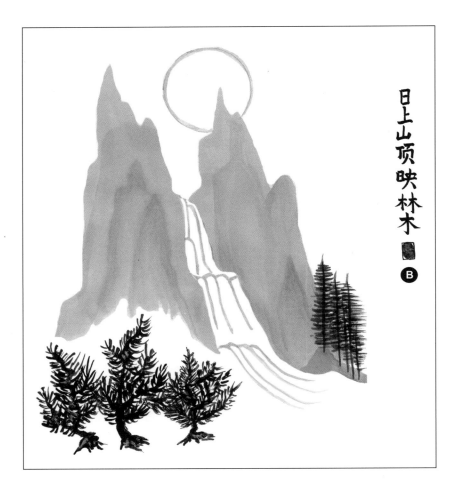

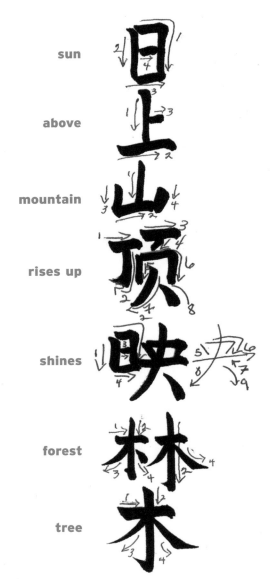

sun

above

mountain

rises up

shines

forest

tree

Adding Calligraphy

After you have painted the landscape, you can describe the scene with calligraphy. Practice doing the calligraphy on a separate piece of paper before putting it in your painting.

The characters translate into the following sentence: "The sun rises over the mountain and shines on the forest of trees." Since you have learned the basic strokes for mountain, water, sun, forest, and tree, you can use this calligraphy to tell the story down the right-hand side of your landscape painting.

Now that you have painted your masterpiece mountain scene on rice paper, very carefully put in the calligraphy that describes the scene. Add your thumbprint and/or your seal.

Mounting your Paintings

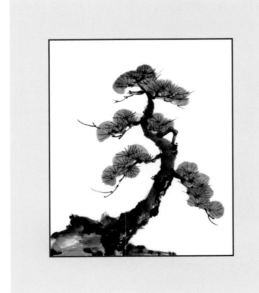

The Purpose of Mounting

Oriental brush painting is done on thin rice paper that leaves puckers when the ink dries. The process of mounting or "attaching" the thin paper onto thicker, more substantial paper reinforces the thin paper and smooths out the puckers. It also helps to protect the paper against damage by insects, such as silverfish, who love rice paper for lunch. After a painting has been backed, you can put it in a mat or mount it as a hanging scroll.

Backing a Painting

The traditional way to back a painting is to use a paste like wallpaper paste. This method works fine with ink but does not work well with tempera paint because the paint tends to bleed out with the moisture from the paste. For this reason, it is better to mount your painting using a modern spray adhesive.

Materials Needed

- All-purpose spray adhesive
- A newspaper spread out to protect the table
- A clean, dry, 3–4" brush to smooth out the wrinkles
- A roll of backing paper with a different surface from the painting paper (you can get this where rice paper is sold), or else sheets of watercolor paper

1. Even up the edges of your painting if they are irregular.
2. Plan the size of the painting, and lay it down on the backing paper so you can add 1–2" beyond the painting. Remove your painting. Cut the backing paper with the extra 1–2" all around.

3. Spray the adhesive in a thin, even layer over the entire piece of backing paper.
4. Carefully lay the rice paper painting on top of the backing paper.
5. With the brush, gently stroke from the center of the painting outward to get rid of air bubbles and wrinkles. Use your finger to smooth out small wrinkles.
6. Let the adhesive dry overnight before moving the paper.

Matting a Painting

A *mat* is a cardboard frame around a picture. Pre-cut mats are available at art supply stores. The mat provides a structure and helps keep the paper and backing flat.

1. Attach the painting to the top inside of the mat with masking tape. Attach only the top, so that the paper can hang down with gravity and stretch. Do not attach the sides, as that can make the paper pucker.
2. To protect the back of the painting, tape a piece of thin tagboard to the top back of the mat.

If you protect your work this way, you can keep it for many years.

Making a Hanging Scroll

Another way to finish a painting is to make it into a hanging scroll, Chinese style, as shown on page 61.

Materials Needed

- Two flat sticks, dowels, or half-round molding pieces for the top and bottom of the painting. The stick for the top should be 2 inches wider than the trimmed painting, so that it is 1 inch wider on each side. The stick for the bottom should be only as wide as the painting.
- Household glue
- Black cord or string to paint black. Use as much cord as necessary to hang the painting the desired height when attached to each end of the top stick.
- Black tempera paint

1. Trim the backing paper around the painting so that the edges of the painting are neat and attractive.
2. Paint the top stick with black paint.
3. Paint the bottom stick with black paint.
4. If using string, paint the string black.
5. When the paint on the sticks is dry, glue the top stick to the top of the outside of the painting so that 1 inch extends beyond the painting on each side.
6. Glue the bottom stick to the bottom of the outside of the painting.
7. Tie the two ends of the cord or string together.
8. Loop the ends of the cord over the ends of the top stick.

Hang the scroll by hanging the cord on a hook on the wall. Hide the knot of the string behind one end of the top stick so that it will not show.

Finalizing Your Paintings

Mat or make a scroll of all your "masterpieces," and keep them where you can enjoy seeing them.

DO YOU Remember?

Do you remember . . .

. . . what was found on oracle bones?

. . . how brush painting is like a soft martial art?

. . . the difference between boned and boneless?

. . . why you need to know about asymmetry?

(hint: look at the section starting on page 6)

. . . how to mix eight shades of gray?

. . . the five positions for holding the brush?

. . . how to load a brush correctly?

. . . how to wash a brush without hurting it?

(hint: look at the section starting on page 12)

. . . the eight basic strokes for calligraphy?

. . . how to make the numbers from one to ten?

. . . the general order in which you make the strokes in a character?

. . . what seals are used for?

(hint: look at the section starting on page 22)

. . . the style of the Lan orchid?

. . . the three parts of the orchid flower?

. . . what TAB and LOB stand for?

. . . how to make a Buddha's eye?

(hint: look at the section starting on page 30)

. . . the different ways to paint bamboo stalks?

. . . how to recognize flying white?

. . . the rules for painting bamboo branches?

(hint: look at the section starting on page 36)

. . . the different ways to make pine trunks?

. . . how to place the pine wheels?

. . . what stroke you use to make a pine cone?

(hint: look at the section starting on page 44)

. . . how to paint the antenna of a butterfly?

. . . how to paint a snail shell?

. . . what makes a bird look like it is singing?

(hint: look at the section starting on page 51)

. . . the forms of water that might be seen in a landscape painting?

. . . what an enso is?

. . . how to put your left hand under your right hand to paint details?

(hint: look at the section starting on page 55)

Books on Painting

Look at the following books to learn more about the topics in this book.

Chieh Tzu Yuan Hua Chuan (The Mustard Seed Garden Manual of Painting), translated and edited by Mai-Mai Sze (Bollingen Series, Princeton University Press, Princeton, NJ, 1978).

This book has many examples and variations of trees, bamboo, orchid, landscape paintings, and traditional Chinese birds and insects.

Evans, Jane. *Chinese Brush Painting* (Watson-Guptill, New York, 1987).

This book has mostly black-and-white, step-by-step paintings of orchid, bamboo, and landscape, and lessons on calligraphy.

Fazzioli, Edoardo. *Chinese Calligraphy: History of Essential Chinese and Japanese Characters* (Abbeville Press, New York, 1986).

This is a good introduction to calligraphy. One of the chapters traces the evolution from pictograms to ideograms.

Heizlar, Josef. *Chinese Watercolor* (Galley Press, London, 1987).

This book has many landscapes in traditional black and white. It tells how to look at Chinese paintings and describes the training necessary to paint them.

Kan, Diana. *The How and Why of Chinese Painting* (Van Nostrand Reinhold, New York, 1974).

This book describes step by step how to paint landscapes in black and white. It also shows the steps to paint orchid and bamboo.

Sze, Mai-Mai. *The Way of Chinese Painting* (Random House, New York, 1959).

This book explains the history and philosophy of Chinese painting. It also has painting techniques for trees and bamboo.

Weng, Wan-go. *Chinese Painting and Calligraphy* (Dover Publications, New York, 1978).

This book covers the history and techniques of painting. It explains seals and their use, and landscapes in black and white.

Yeh, Ning. *Chinese Brush Painting: An Instructional Guide* (Silk Era Corp., Huntington Beach, CA, 1988).

This book contains step-by-step directions for painting bamboo, orchid, and flowers, and explains the philosophy of harmony and contrast.

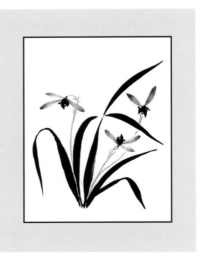